Yankin' and Liftin' Their Whole Lives

SHAWNEE BOOKS

TEXT AND PHOTOGRAPHS BY **Richard Younker**

WITH A FOREWORD BY JERRY ENZLER

Southern Illinois University Press *Carbondale and Edwardsville*

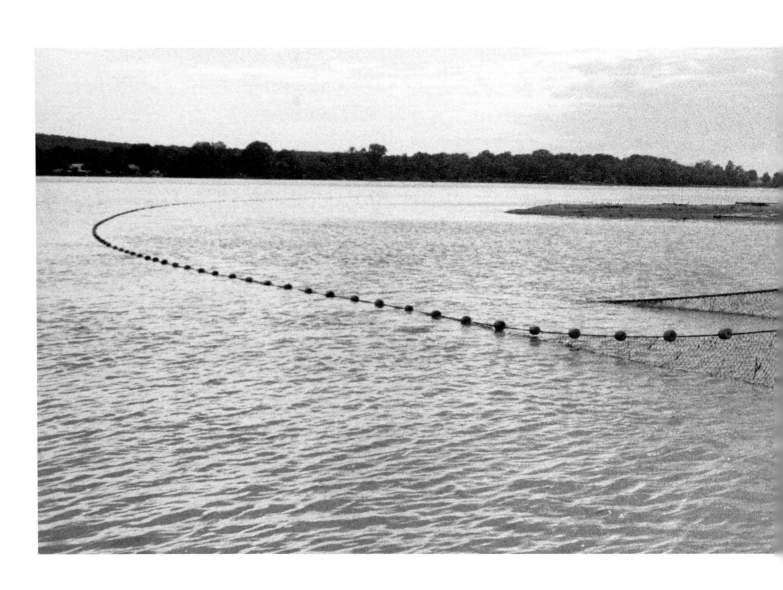

Yankin' and Liftin' Their Whole Lives

A Mississippi River Commercial Fisherman

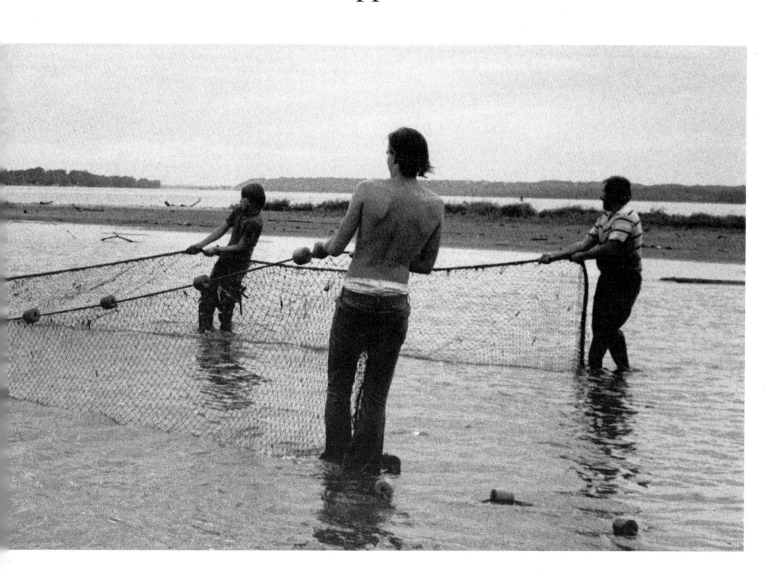

Library of Congress Cataloging-in-Publication Data

Younker, Richard.
 Yankin' and liftin' their whole lives : a Mississippi River
commerical fisherman / text and photographs by Richard Younker ;
with a foreword by Jerry Enzler.
 p. cm. — (Shawnee books)
1. Fisheries—Mississippi River—Anecdotes. 2. Fisheries— Mississippi
River—Pictorial works. 3. Putman, John, d. 1997. I. Title. II. Series

SH221.5.M58 Y68 2000
639.2'1'0977764—dc21
ISBN 0-8093-2337-0 (alk. paper)
ISBN 0-8093-2338-9 (pbk. : alk. paper) 00-035762

The paper used in this publication meets the minimum requirements
of American National Standard for Information Sciences—Permanence
of Paper for Printed Library Materials, ANSI Z39.48-1992. ♾

Text and jacket design by Erin Kirk New

Title page illustration: The Gilpin crew pulls on seine near an island
on the Mississippi River across from Dallas City.

To my dear friend Junnie Putman

Contents

Foreword

Richard Younker's *Yankin' and Liftin' Their Whole Lives* puts you on the river with a captivating portrait of Junnie Putman, his family, and their pursuit of life on the Mississippi at Bellevue, Iowa.

Here are the sights and smells of the Mississippi, told by those who harvest the river. You'll see the river above the surface and below, in open water and through thirteen inches of ice. You'll strain with the weight of three hundred thousand pounds of buffalo in seine nets and sag with disappointment at empty hoop nets with holes cut by snapping turtles. You'll see an ice jam one hundred feet wide and forty feet high and hear it breaking up with the sound of "ten express trains" as it chases three fishermen in their eighteen-foot boat.

Richard Younker writes authentically of the complex lives of these river dwellers. He visited the Putman family some fifty times and spent nearly one hundred days on the river around Bellevue, photographing Junnie and his family and documenting their countless stories and images of commercial fishing, trapping, and hunting.

From the opening chapter, with its violent background, to the closing account of Junnie's passing, the narrative overflows with personal anecdotes, river ramblings, and observations on the seasons and wildlife. It's the story of an independent people who often carve only a marginal living from the landscape, a labor so fraught with frustration that the fishermen not only compete with their neighbors or relatives but also lash out at them with devastating consequences. And yet these men show surprising tenderness to their rivals and families.

The Mississippi has many stories, of native hunters and fur traders, flatboat families and steamboat pilots. Today there are still many Mississippi Rivers: a river of egrets, a river of giant tows, a river of power plants. Here you'll be immersed in one of those rivers in a story of American folk culture and of carefully held secrets passed on through family lines.

This is not an interpretation or synthesis of the trade. It's a recounting and a documenting of life as it happens, one day bright, the next bitter. It's a story of nature keenly observed by those who note pollution and species depletion even before the experts. It's also a story of perils on the river as well as hoopla raised at a tavern on the way back from market.

Commercial fishing is nearly a lost profession. Most cities on the Upper Mississippi once had a dozen or more full-time fishers, and they passed on their skills to the next generation. Now each city might have a single commercial fisher.

Chicago once had sixty-five markets to buy fish from the Mississippi; now there are four or five. Fish are trucked in from six hundred miles distant, bypassing the catch from six miles away.

To read this book is to be invited onto the fishing boat, to eavesdrop on the conversations of the crew. The narrative and photographs open new sloughs for you, introduce new channels, places you knew existed but had maybe observed only from afar.

Younker gathers a net around the fleeting story of commercial fishing, trapping, and hunting, documenting it in image and word. Read it in summer on the river's banks, and you'll know exactly what those commercial fishers are doing as they pass by. Read it in winter in your easy chair, and you'll feel the lash of a forty-below windchill when these men harvest fish below the ice.

Yankin' and Liftin' Their Whole Lives shows the lifeblood that runs through this family, that runs through this river we call Mississippi.

JERRY ENZLER
Executive Director
Mississippi River Museum
Dubuque, Iowa

Preface

Perhaps it is in the blood, for my ancestors at Cork, Ireland, fished commercially 120 years ago. Then, for my first photo essay in 1974, I documented that industry on northern Lake Michigan, riding the still pool off of Epoufette or the murderous tides that cut through Mackinac's narrow straits where Lake Huron empties into Lake Michigan. For a second story that year, I wrote of the Chippewa Indians near Sault Ste. Marie, Michigan, who were fighting for their treaty rights that centered on commercial fishing.

Over the years, I thought of returning to the Upper Peninsula to pursue book-length projects. Luckily I waited, for the deepwater fishermen generally use only one type of gear, either gill or trap net, and then the November gales and December ice keep them ashore four to five months. But their Upper Mississippi River counterparts suffer no such constraints. They employ up to five different gears and not only fish (through the ice) during winter but also enjoy their most generous paydays then.

In September of 1988, I met John ("Junnie") Putman of Bellevue, Iowa, then sixty-one years of age, who had fished commercially without break for almost forty-seven years. The circuitous route that led me to the Putman family

perhaps typifies the serendipitous nature of free-lance journalism. While embarking on a Mississippi River project, I was referred to the Dickaus of Thomson, Illinois, a commercial fishing family. At the end of a brutally hot day I had spent with them on the river, they wondered if I had ever photographed a particular turtle trapper, one who plied the waters near the Wisconsin River.

Arriving in nearby Cassville, Wisconsin, some weeks later, I called the gentleman, who invited me over that evening but then related that a recent heart bypass operation had ended his days on the river. After a nice chat, he suggested that I call Al Liebfried, from Potosi, Wisconsin, some miles south, who was still trapping turtles and selling their meat to local restaurants.

After lunch I dropped two quarters in the pay phone slot and let it ring ten times. Every hour or so for the next two days, driving around the area, I dialed without response. Finally, upon arriving in Potosi, I asked a bartender where Mr. Liebfried's residence might be. "Which Al Liebfried?" he asked. As it turned out, there were two among Potosi's 736 residents, and I had been ringing the insurance salesman. "The other one lives right across the street. He probably just got off the river."

"A photographer!" boomed the strapping six-footer as he lashed a fifteen-pound turtle to a post for butchering. "What do you want with me?" he asked. "You with the state police or somethin'?"

"No," I said.

"A photographer! What you want my picture for? You got any identification?"

After an hour of rigorous interviewing ("You sure you're not with the DNR?" he quizzed, referring to the Department of Natural Resources), Mr. Liebfried allowed me to photograph him butchering in his basement and in the yard with his son before we adjourned to the tavern across the road. Around 10:00 P.M., I asked if I could photograph him trapping turtles. "You wanna get me in trouble?" he shouted, then more quietly, "The season's over, no more trappin' for three months. But come back second week in December when they hibernate in the mud; you'll really see somethin' then."

Next morning I traveled some forty miles south to Bellevue, Iowa, where the brother of a commercial fisherman I had photographed two years previously lived. I thought the gift of some photographs would make a good introduction.

"Thanks for the pictures," said the fisherman, "but I gotta set lines now."

"Trotlines?" I asked.

"Yeah . . ."

"What are you going to bait them with?"

"Crayfish . . . say, don't you gotta be goin' someplace?"

"No, I'm in town for a couple of days."

"Well, I'll show you my setup, but then you gotta leave."

After looking at Wayne Kress's tanks with live catfish, I stood my ground. "You ain't gonna try to hang around me this afternoon?" he accused, narrowing his eyes.

"If it's okay with you . . ."

"Not really," he said, leading me to the stairway. I asked him a few questions, which he answered politely but with growing impatience. For some three hours, though, I insinuated my company upon Wayne and his wife, Rita, who joined him to bait their twenty-five trotlines ("Oh, Wayne, why don't you let him take your photograph?"), finally getting some interesting stories and a nice portrait of Wayne.

But while chewing on ham and mashed potatoes at the Riverview Restaurant that evening, recalling Wayne's burly physique, menacing gestures, and scowls through a thick beard, I decided it was time to return home. Eight days of brush-offs, real or imagined, and meeting people at the wrong season were quite sufficient. So I told the Anchor Inn's proprietress, Jan Schroeder, with whom I had had several pleasant conversations, that I would be checking out the following morning. But she had other ideas for me. "Oh, no," she said, "you're not going back to Chicago until you meet the Putmans."

That day I met Junnie as he began to clean the morning's catch in his cinder-block shed, originally a fish market run by him and his wife, Mary, but now used to store gear or to sit with friends and relatives and recount the day's events. "What do you want?" he said. I began paging a magazine to one of my photo essays. "Where do you want me to stand?" he asked.

". . . and I've had this book published . . . ," I said.

"Is this better by the light?" he asked, holding a ten-pound catfish in one hand, a knife in the other.

Since then I have been out to see the Putmans numerous times, more and more to socialize as my book neared its completion. Around the fifth of my fifty-some visits, I had gained, after a few harrowing moments, the trust and

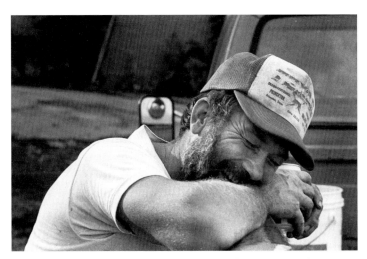

Wayne Kress, Junnie Putman's neighbor and a commercial fisherman, relaxes after baiting his trotlines.

friendship of his family. During my stays of seven to ten days, I would meet Junnie at 5:15 A.M. and go to the river either with him or him and his crew, watch him dress his catch ashore, ride to market, stop at two or three taverns on the return trip, and spend evenings with him and up to a dozen friends—fishermen, farmers, relatives. In his shed, they drank and chatted, swapping stories about hunting, trapping, and fishing—wood and river lore. In between were funerals, weddings, parties, and celebrations where the room spun from dancing.

A way of life unfolded before me, one that recalled an earlier time. Undiscussed went all the issues of the late twentieth century. Shut out of the cinder-block walls were Watergate, My Lai, civil rights, space travel. Indeed, some December evenings when a bewhiskered Junnie Putman walked in off his trapline, a fur cap topping his six-foot-one-inch frame, a revolver hanging from his hip, I half expected Davy Crockett or Jim Bridger to come stomping in behind him, shaking off the cold.

I have eventually become a member of the extended Putman family. Harsh words and tender ones were spoken in my presence; old grudges were rehashed within my hearing. But best of all, tales—from long ago and from the present—were recalled, most of them either amusing or dramatic.

I have learned much aside from wood and river lore. For example, in November 1990, I phoned Junnie to tell him that four pages of my photos of him would appear in the *Chicago Tribune Sunday Magazine* that following week. His reply took me back to a different time, a different place. "That's good for you, Rich," he said, "but the important thing is, when you comin' out again?"

Greetings and good-byes are among the special memories I have of Junnie and his self-effacing kin. Once, after a year-long absence, I surprised Junnie's brother "Big Dave" Putman and his family sitting in their yard. "Look who's here from Chicago!" said Big Dave. But before he finished the sentence, his wife, Thelma, rose and walked beside me, taking my hand and clasping it as we stood there some five minutes.

Junnie and Dave insisted I stop by their sheds before motoring back to Chicago. Once, Junnie was in the house finishing breakfast, so I went to Dave's first. We moved out of his damp structure, ambling into the first, warming glow of sunlight. We discussed how he would fish that day as well as in the coming months and his prospects for that period. For a moment, we shuffled our feet wordlessly or looked up at the palisade that has towered over Bellevue since the Pleistocene Age. Then Dave said something that contrasted with his coarse and heavy work and his rare but volcanic

temper. "When you comin' back?" he began in a near whisper. "Because we really miss you; we think about you all the time."

After saying good-bye to Junnie ("Watch your back in Chicago, Rich"), I stopped at Wagner's Convenience Store for coffee. Barb Mickel, Junnie and Mary's next-door neighbor, was there. "You goin' back this morning?" When I said yes, she replied, "Well, we'll see you next time." Then my some-time dance partner and I embraced. "Now," she said, "you're gonna miss us, aren't you? Bet you cry all the way back to Chicago."

Junnie passed away on October 1, 1997. The family asked me to say something at the eulogy. I concluded by recalling that on my way out to Iowa for the third time, crossing the river at Savanna, I was only able to get country music on my radio. I didn't like country music then, I said. I also said that this seemed to symbolize an unbridgeable gap between myself and Junnie, as he was rarely out of earshot of country music. Too, he was a country boy and I hailed from the city. I was a college grad while neither Junnie nor his fishing brothers went beyond eighth grade. I enjoy talking about history and poetry while he appreciated discourse on hunting, trapping, fishing, and animal lore. I, though brash of tongue, have talked my way out of many fights while Junnie, at times soft-spoken, hadn't, I was sure, backed off from any.

Concluding, I said, "I still don't like country music, but today, after fifty visits, I've come out to Bellevue to say good-bye to the best friend I've ever had."

Acknowledgments

I would like to thank the Putmans for providing complete access to their lives and stories and, more importantly, for admitting me into their family, a relationship as close as my own flesh and blood, perhaps closer.

My appreciation goes to Junnie, with whom I spent nearly one hundred days alone on the river and with whom I hoisted glasses on the way home from market; to his wife, Mary, who poured out stories and experiences from her life and is a dear friend; and to their daughter Peggy Hayes, who also helped guide me through relationships with her family. Warm thanks to Tami and Ron Purvis and their children.

Thanks go to Junnie's brother Big Dave, with whom I chatted for hours on many a drowsy afternoon or frosty morning, and to Little Dave, a good friend, too, who one day, in response to an observation, uttered the words that ended up as the book's title. Thanks, too, to Richie Putman, Junnie's older brother, who shared some of his marvelous tales and friendship, and to his son, Ricky.

Thanks to Doug Griebel, whose mischief, friendship, and stories I'll always appreciate.

Much appreciation goes to Junnie's cousin Eddie Putman (and wife, Angie) for hours spent patiently explaining the seine or hoop net's intricacies, as well as for spinning marvelous stories. His life would make a book as well.

Special thanks to Mike Hayes for good company and to his children, John Hayes and Tricia Schwager.

Thanks to Billy Reistroffer, who livened many an evening's chats in the market, as did Jimmy Budde and Beaver; and to Raymond Putman and Vinnie Putman, whose company I enjoyed.

My gratitude goes to Thelma Putman, Big Dave's wife, and Cindy Putman, Little Dave's wife; to Big Dave's other sons, Steve, who provided several quotes and is a friend, and Larry, a friend as well; to Larry's wife, Ruth; to Grace Steines, Irene Steines, and Betty Budde, Junnie's sisters; to Yolanda (Ciulla) Griebel; and to many, many more.

Much thanks to Mike Schafer of Schafer's Market, Fulton, Illinois, and Marion Conover of the Iowa Department of Natural Resources for helpful information.

Thanks, too, to Bellevue's innkeepers and homeowners who put me up at reasonable to charitable rates and with generous hospitality, particularly my dear friend Hilda Melton along with Fran and Milt Perkins, now gone, and Chris Zraick of Mont Rest Bed and Breakfast. And a special thanks to Jan Schroeder of the Anchor Inn, who first introduced me to the Putmans.

I would like to acknowledge John William Putman (10/11/54–8/29/70) and Michael Hayes (11/6/69–10/12/86), Junnie's son and grandson.

Those first few days back in Chicago after being on the Mississippi, everything seems so artificial and insincere. Good-bye, Bellevue. See you again when the weather gets warm.

Yankin' and Liftin' Their Whole Lives

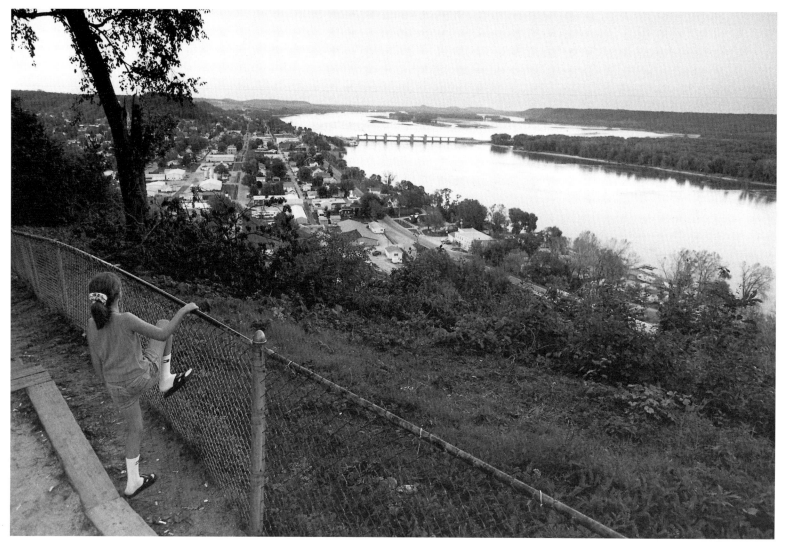

Junnie Putman often fished two miles north of the bridge (dam) shown in the background of this view
of the Mississippi River from the state park in Bellevue, Iowa.

1 Introduction

Nestled between two palisades, the geography of Bellevue, Iowa (pop. 2,239), forms a subtle bowl or amphitheater. It begins atop a hill and slopes gently eastward several blocks to Riverview Drive, which in turn overlooks the Mississippi River by some thirty or more feet. Patrons of the Riverview Inn in downtown Bellevue can look out its picture window on winter mornings and see eagles flying in and out of rising mists. Just upriver, in the warmer months, there will be a towboat pushing a barge or two, churning water, awaiting clearance through the Bellevue lock. Across the river, which narrows to a mere three hundred yards at this point, stands an unbroken line of trees. Behind them, however, one must traverse a nine-hundred-yard maze of sloughs, rivers, soft ground, and muck before standing on firm Illinois ground.

Perhaps isolation enhances Bellevue's beauty. To reach it from the east, one must either cross the bridge twenty-three miles north at East Dubuque, Illinois (pop. 1,914), or motor a like distance south to Savanna, Illinois (pop. 4,100). Farmland rolls away from the north and west; rugged hills rise to the southwest. Neighboring villages lie a dozen or so miles off: Springbrook, Otter Creek, La Motte, Green Island, all dots on a sea of corn, soybeans, and rolling hills. Outside of town, the only sounds heard are a corn dryer humming, a farmhouse door slamming, or, at night, coyotes barking or the sound of owls. "Oooh yeah, they hoot like hell," says

commercial fisherman Junnie Putman while running his traplines one late November evening. Otherwise, the whole world seems silent.

Remnants of an earlier time linger around Bellevue. In three old, vine-covered structures, one shuttered, another a Laundromat, workers once processed clams in button factories. Littering the shore below one are thousands of washboard or buckhorn shell remnants, each punctured with what look like four or five bullet holes.

Junnie Putman's daughter Peggy Hayes tells of stealing into these abandoned plants and skittering discards across the floor, or plowing into a thousand-shell pile, which clattered like bones from an old pirate grave. More severe were her parents' rebukes when she explored the abandoned icehouse, for there, it was said many years past, a young girl lost her arm in an accident with the auger.

At the far south end of town, a solid, red four-story structure stands above Mill Creek spillage, some twelve feet across. Once a flour plant, originally powered by a great waterwheel, the building now houses the Potter's Mill restaurant where waiters and waitresses glide over the deeply rutted oak floors.

Ghosts stir three blocks up the road as well. Junnie (long *u*) Putman, the subject of this book and one of the last

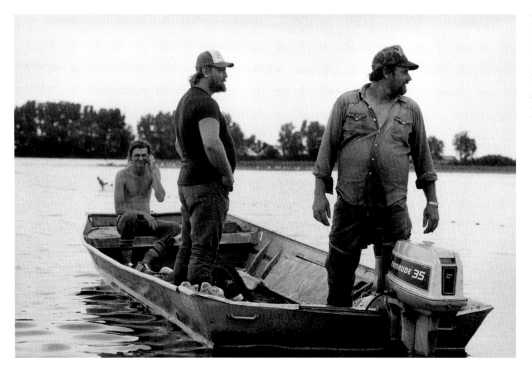

Men of a commercial fishing crew (run by the Gilpin family) near Dallas City, Illinois, watch seine from john-boat for movement, some 150 miles south of the Putmans.

full-time commercial fishermen on the Upper Mississippi River, passed away on October 1, 1997. Outside his fishing shed sits a johnboat, now empty of gear. Leaning against the wooden fence are a dozen hoop nets, mesh stiffening from disuse. Inside rest thirty trotline boxes, replete with lines, hooks, anchor, and bobbers, awaiting a nod from the auctioneer on September 27, 1998, before they assume new ownership and spin into usage again.

Bellevue's town site was laid out in 1835 and named for one of its first settlers, John Bell. Twenty-eight years later, the first Putman, Jacob Sr., fled here from Mount Carroll, Illinois (not Galena, as some of the family claim), to evade service in the Civil War. Taking residence in the town's south end, he,

his offspring, and later arriving relatives prospered so that the section was referred to as "Puttville." Jacob eventually was "shot in the right temple by some person unknown to the jury" in 1880, a verdict later reversed to suicide, one that the present family protests to this day.

"By golly," says Eddie Putman, Junnie's cousin and a retired commercial fisherman, "if you look in this book, *Jackson County Records,* you'll find more murders and violent deaths locally in civilian life than those that's died in all the wars we've had combined." As for Eddie's great-uncle Oscar, documents reveal that he died as a result of "injuries from unknown cause along the Chicago, Milwaukee and Southern Pacific railway right of way between the hours of 11 A.M., 12/24/07 and 6 A.M., 12/25/07 of the following day."

Eddie explains, "He'd missed the Bellevue stop, so when he got off at Green Island they wouldn't issue him another ticket to go back, [they] just said tell the conductor what happened. Well, I hoboed freight trains in the 1930s and I know how rough them railroad bulls can be. No one bought it, see, an argument ensued, and by golly, they threw him off the train."

Indeed, mayhem remained an integral part of Bellevue and most other river towns into the 1970s. Standing at the corner of Fourth Street and Second Avenue on a balmy October afternoon in 1998, Eddie's son, Terry, points to an innocent looking building across the street. "The old bucket of blood," he says of the now shuttered tavern. "Used to be a killing in there every week. One night a guy walked out of there and fell face down into the gutter. Drowned in three inches of water."

The Indians called the area around Bellevue "Big Timber" and considered it prime hunting and fishing grounds. The Putmans either felled trees, worked the timber boats, guiding hundreds of thousands of feet of logs down the river, or labored in sawmills. Around 1927, Junnie's father, John, took up commercial fishing, a trade he pursued until about 1950. Junnie followed in his father's footsteps, starting around 1940. Junnie's brothers Big Dave and Richie were also commercial fisherman, while brothers Ralph and Raymond worked tugboats and for the railroads, respectively. Only one of their six sisters, Grace Steines, worked in the fishing business, running a fish market.

In 1950, Junnie wed Mary Bowman, who had grown up on a farm outside of Bellevue. They had three children: John, Peggy (Hayes), and Tami (Purvis). Like many fishing wives, Mary participated in several phases of the commercial operation for some ten years or so.

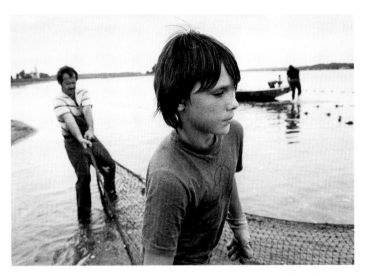

Part of the Gilpin crew near Dallas City pull in seine with about two thousand pounds of drum.

Mary has never complained about the rigors of commercial fishing, but Peggy speaks of her grandmother's generation. "Times was tougher in the thirties and early forties. My grandma, Junnie's mom, worked harder than any of us, most of the men, too. She raised eleven (a lot of them Putman boys was a handful), cooked for them and Grandpa, and done a lot of fishin' work as well. She dressed and smoked fish, and then they had her carry them five-gallon tubs filled with fish guts out for garbage pickup. Two at once! You'd have a hard time haulin' one, I bet. That's how she died. At thirty-four of an aneurysm in the brain. Carryin' out two tubs of guts. Dad always thought Grandpa worked Annie too hard. He blamed him for her death. That's where all the bad feelings started between Junnie and Grandpa."

By the end of World War II, fishing was a booming industry. Mike Schafer, who runs Schafer's Fisheries near Fulton, Illinois, says there could have been as many as three hundred full-time fishermen from LaCrosse, Wisconsin, to the Quad Cities, a stretch of almost two hundred river miles. The number today has dwindled to about twenty-five. Many complain that it is no longer possible to support a family from the industry. Schafer concedes, "All the remaining full-timers are older [and] have already raised their children."

Speculation varies on the industry's decline. Marion Conover of the Iowa Department of Natural Resources (DNR) says, "Even though people around here prefer the river fish, the [catfish] farms provide uniformity of size and taste. Why, you can get two river catfish from the same pool that would taste like different species. So now you've got restaurants in the Putmans' hometown four blocks down the street from them that have their fish trucked in from Mississippi ponds six hundred miles away."

Junnie complains that the computerized dams raise or drop the water level too often, spooking species and chasing them inshore or back into the channels. The result is that the fish change their location so frequently that no one can fish them successfully for more than two consecutive days.

Lorin Hager, the lockmaster at Bellevue, offers a different explanation. Computers only try "to maintain a river depth between eleven feet four inches and eleven feet eight inches, so you won't get dramatic shifts from us. But since the farmers drained their potholes and marshes, the developers put in stores with parking lots, you don't have your holding areas for rainwater any more; it just runs right off into streams or into the Mississippi directly."

Pollution, too, is often cited, although the area of Bellevue has never banned fishing because of it. And Mike Schafer claims the river is now cleaner than it has been in some time, citing the Environmental Protection Agency's more vigilant attitude toward industrial waste and the lower levels of fertilizers and pesticides allowed in agriculture.

Or is it the new work ethic? Junnie complains, "Too many distractions with them kids today—video games, television. No one wants to put in them fifteen-, sixteen-hour days [which is required to run a trotline operation] no more." Mike Schafer puts it differently: "Oh, you got guys who work when it's easy, spawn times [spring], bunch times [mid-autumn]. But I need a steady supply of fish, men who work when they're plentiful and scarce."

Fish prices have plummeted in recent years. Around 1985, dressed catfish, which brought as much as $1.50 a pound, began selling at fifty cents and less. Carp, once the mainstay of commercial fishing, is priced too low to handle at six cents a pound. "Jewish families [who used to make gefilte fish from it], or at least the younger ones, are falling away from their practice more and more," says Schafer, "so there isn't your call for it."

Many commercial fishermen think they can pinpoint the source of the drop-off: the part-timer. Local men, from construction workers to farmers and factory workers, raise nets and set lines on their days off. The revenue they receive for these labors is usually beer money to them; so with a steady paycheck in hand, they do not mind the lower prices offered to them.

But Eddie Putman, who retired around 1980, says, "Oh, I seen the end of it one winter twenty years ago. Me and the boy—this was before he hurt his back—was makin' a haul

just above Crooked Slough. Oh, they was bunched up so thick in there we hardly closed the seine. I bet we had sixty thousand pounds of buffalo penned up in there. And Terry got so excited, see, 'cause, hell, we was gettin' forty cents a pound; he figured on buyin' a new car with it. Then when we trucked 'em into Chicago, they would only pay us six cents a pound. That's right, 'Take it or leave,' they said.

"See, what happened is they used to have sixty-five markets in Chicago. But over the years it dwindled down to four or five; then they pretty much had their way with us. Oh, their checks would bounce, too. The Smink brothers, who used to live next to Mary and Junnie, they had a whole cigar box full of checks that wasn't no good. And then when you'd hire a lawyer, go after 'em, why, they'd declare bankruptcy. God, yes, time and time again this one buyer did. And then when they finally turned him down he committed suicide. Not long after that I quit. No, sir. From then on I just run traps." Most of the local markets, including Schafer's, have been quite fair with the fishermen, according to Eddie and Junnie.

Junnie fishes in a twenty-foot johnboat, a craft squared off at either end. Junnie sits in the hollowed-out stern to run the boat, stores trotline boxes ahead of that, and keeps his catch in a hold in front of that while using the raised platform in the front of the boat for landing the fish. He slides the boat into the water some three miles above the Bellevue Dam and fishes the largely open flowages, little better than a mile wide, overlooked by low, wooded hills. South of town some five miles, he works more variegated waters, navigating a series of backwaters to find the brackish pools of the snapping turtle or terrapin. Or in the two hundred feet between a timbered island and Illinois's forested shore, he sets and raises nets. Two miles farther south stands a steep, sloping bluff ("Whoever reaches the top is mighty glad they did," says Dave Putman), sometimes four hundred feet high. Its heavily timbered slopes, which eventually give way to sand dunes, front the Savanna Ordnance Depot. During World War II, it housed a number of Italian POWs ("We used to see 'em chopping weeds down by the river," says Mary Putman. "A lot of 'em was good lookin', too"). Today, antiquated munitions are detonated there, the roars audible a dozen miles upstream, clearly distinguishable from the pops of nearby rifles or shotguns. Thus, the area is known as the Proving Grounds. Its waters are usually filled with fish since nets used to be banned there (perpetrators were heavily fined), although Junnie and his six-man crew, for $2,500 per operator per year, may lease it for the winter season.

The commercial fishermen of the Upper Mississippi (from St. Louis north) may bring a variety of species to market. The flathead (catfish) is tapered to its tail and a dull yellow underneath. Bewhiskered, they average four or five pounds on trotlines, somewhat larger in nets, though fifteen-pounders are not unusual, with their elders topping fifty, even a hundred pounds. The channel catfish, bluish in shade and freckled, flourishes in moving water, seldom topping five pounds. Fickle eating habits make both species a challenge to commercial fishermen.

Sharing river bottoms are German imports: the carp, an oversized member of the minnow family, which not infrequently weighs in at twenty pounds, and its native-born

lookalike, distinguishable by its greener cast, the buffalo, which vacuums crustaceans off or from under riverbeds. Coming in at twenty pounds or more (and earning thirty cents per pound), this sucker family member fills many a fisherman's tub, bucket, or boat hold. All three of the local species—bigmouth (known as pug), smallmouth (or highback), and black (roachback)—are considered delicacies by the Chinese and Thai.

Drum are named for their staccato thumps against fish box bottoms. Locals call them perch or sheephead. They weigh in at a dozen pounds or so, with twenty-five-pounders not uncommon, although buried in the middens of old Indian campfires (according to John Madson in his excellent book, *Up on the River*), one can find skeletons that may have supported two hundred pounds of fish. Its thirty cents a pound price tag makes it a keeper.

"We used to ship a lot of gar to Chicago, to the coloreds," says Eddie Putman. "They said it tasted like chicken. But they ain't as much call for them," either the short-nosed (or "billy gar"), which goes up to three pounds, or the long-nosed gar, which might reach twenty. Long of snout and slender of body, both resemble underwater logs as they float toward prey before striking in a flash.

Now rare is the lake or "rubbernose" sturgeon. Overfished, these monsters used to reach eight feet and stretch scale springs at three hundred pounds or more. Commercial fishermen today must toss them back into the flow. Not so their smaller relation, the shovelnose or "hackleback" sturgeon. Paddlers of the currents, these would be outsized at four pounds; yet smoked they are considered the filet mignon of

these watersheds. Occasionally, a fisherman will haul in a run of this species; but their dwindling numbers are reflected more by the stray gaffing itself against a trotline hook.

A variety of game fish surface here as well. Crappie, bluegill, walleyed pike, and bass, large- and smallmouth as well as striped, have long inhabited these waters. More recently, northern pike have found their way here. In fact, they now flourish, sometimes crowding food fish species from hoop net chambers. They, like the rare muskellunge, after being dehooked or untangled, must be carefully rolled from the commercial fisherman's boat, swimming free for the sportsman.

Seasons and species dictate what type of gear Junnie and other fishermen use during the course of a year. When fish are still bunched together in early spring, Junnie begins with heavy meshed seines, which will hold in their great numbers. Then, with the species' dispersal, he casts the silky meshed trammel nets, some hundred yards in length. By May he will set cage-like hoop nets, both for turtles and fish. June brings on four months of trotlines. Fishermen spend a good deal of time determining what baits the fickle catfish will try to take off their hooks. Later, in October, he tries trammel nets once more, except on those days when floating leaves will clot his mesh and make the removal of fish too difficult for profit. Late fall, when fish bunch up in the sloughs and shallow waters, he stretches the seine in their proximity. Finally, when the ice freezes solidly enough to support the weight of a man, he and his crew shove their seine below its crust. During this shivering time, the really big catches have been taken, upwards of two hundred thousand pounds in a single net.

The Putmans supplement their income from many other sources, such the sale of clams. Junnie floats his crowfoot bar

upon the water, its hooks dragging along the shallows. Clams feeding with valves wide open will clamp upon them so firmly that their valves must be pried apart with a flat blade.

Younger men, however, who supply most of the shells use scuba gear to grope around in the river bottoms. These laid-off construction workers and farmers who have fallen on hard times burn out in a few years, since the work is exhausting and dangerous. One of them describes conditions below, trailing an air hose behind him. "You crawl on that muddy bottom and feel for clams because, basically, you're workin' in a closet with the door shut; it's that dark. But you better know the area, too. Can't let that air hose curl around a branch or somethin'; cut off your oxygen.

"Tugboats is another hazard. You think that motor ain't strong; just stand on the bank and watch it draw down the water level five inches. Last week I tried stayin' under with the fifty-five-pound weights around my waist. Well, I want to tell you that suction pulled me four feet off the bottom. Without the ballast I would have gone right up into that propeller. Been feedin' the fishies from here on down to Grafton."

Butch Ballenger (who owns the Mississippi Valley Shell Company) and Tom Swann set up "shell camps" in riverfront parking lots and abandoned gas stations. They ship the cooked-out shells by the containerful to Japan. Their BB-sized pellets are cored out and implanted into saltwater oysters, which eventually grow them into cultured pearls. Up to twenty shellers, loaded johnboats in tow, have their catches evaluated (shells must be milky white, not veined or cloudy), weighed, and purchased. Stories spill out during the two-hour wait, such as this one heard at the Dallas City, Illinois, marina, some 165 miles downriver from the Putmans' home.

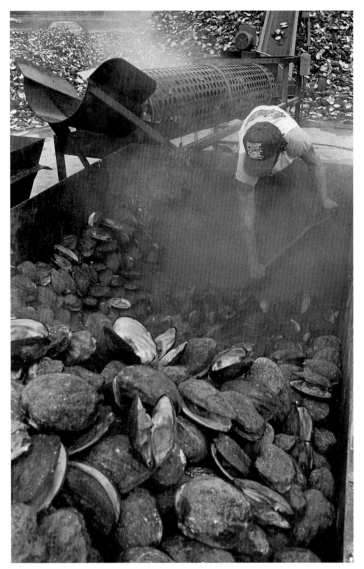

A worker shovels clams that have had their meat cooked out at Butch Ballenger's Mississippi Valley Shell Company in Muscatine, Iowa, ninety miles south of the Putmans. Shells are shipped to Japan where cored-out pellets are implanted in saltwater oysters to make cultured pearls.

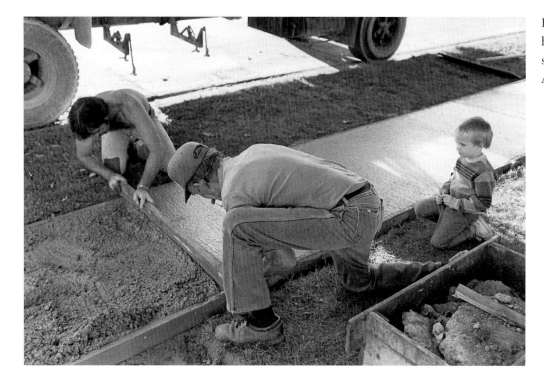

Big Dave Putman *(foreground)* and his son Little Dave level off a new sidewalk while Big Dave's grandson Austin watches.

Bob: I hear Jimmy down by Grafton was using his lantern a few nights ago. Saw this clam by a stump, but when he reached for it, somethin' took hold and give his fingers a good bite. Well, he come up, his hand was all right, but the ends of his glove was all chewed off. Brand new, just bought 'em that morning. Boy, that riled him. Said, "I'm gonna get that so and so." Back down he goes, this time with a knife, and wrestled the critter. They say he stayed under five minutes. 'S a blue [a catfish which grows to outsized proportions but is rarely seen up the Putmans' way]. Forty-pounder. Boated him and there was scars all over his back. You know how them blues love to fight.

Ed: It ain't only the big ones. I've caught six-inchers that had nips all over 'em. But don't that sound like ol' Jim, gettin' steamed up about his gloves.

Bob: Yeah, one thing if they was worn ones, but he wasn't gonna let him off for no day-old pair.

Trapping comprises a larger part of Junnie's supplemental income. From early November until mid-January (into April for beaver), he walks the river bottoms and occasionally the hills, setting and raising traps. Mink, beaver, muskrat, and raccoon are lured into their jaws. Until 1994, a good mink

pelt brought in eighty dollars, while a coon, richly pelted, could bring in forty-five. However, the recent surplus of pelts, along with the rising protest against furs, has sent their prices plummeting by half. Muskrat, over the last six years, has dropped from two dollars per to as low as fifty cents.

Junnie hunts and fishes for much of his family's protein. Deer, turkey, duck, goose, and various species of fish occupy a good deal of freezer space. As Mary states, "We used to have walleye [or sauger, a game fish and illegal to take commercially] twice a week. My husband didn't have time to go fishin' with a pole and line. But when a couple got caught in his nets, he brung 'em home. He'd hide 'em in his lunch bucket. No one ever thought to look in there.

"But after a while he had to stop. The DNR hired so many more wardens, and all of 'em can make arrests now, which they couldn't before. Oh, they just swarm out there! Every time you look there's one on the ridge with his binoculars, lookin'. Used to be just one game warden for the whole county and that was it.

"Oh, I sure could go for some pan-fried sauger right now!"

Until about 1980, Junnie guided tourists to hunting spots he had known since childhood. His stipend was as much as two hundred dollars a day.

Ghosts haunted Junnie from 1968 until his death and disturb surviving members of his immediate family to this day. "Our Johnny died [in an auto wreck at age seventeen]," says Mary. "I didn't disturb nothin' in his room for a whole year; wouldn't change the bed sheets or even make the bed. Those first few weeks I'd go upstairs sometimes and lay atop the covers, just to catch the smell of his body. As if that was gonna bring him back.

"Another stupid thing I did: I'd clean the house and put together a great big home-cooked meal, have it waitin'. I thought if I did all that, he might come back. No, actually I expected him to. Of course, when he didn't, that brought me even lower, made me more depressed. Oh, there was a lot of foolish things I did."

Memories of Johnny and of a beloved grandson, Mike Hayes, who died in 1986, hover over the Putmans' lives. They arise in everyday conversation and populate family dinners and reunions, occupying the empty chair.

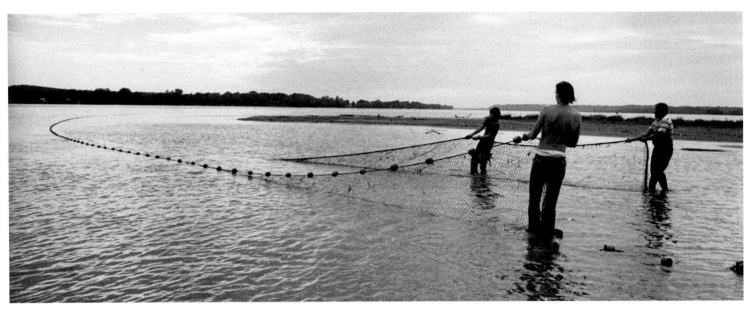

The Gilpin crew pulls on seine near an island on the Mississippi River across from Dallas City.

2 Seine, Open Water

When autumn winds hustle through the backwaters, there comes a lull in a commercial fisherman's schedule. Leaves, newly fallen, form such a carpet as to clot his trammel nets, making prolonged removal of fish unprofitable. Even when the leaves have floated off downstream or sink, fishing becomes impractical for another reason: the fish refuse to feed.

Perch and buffalo, instead of haunting currents and eddies, seek out still waters behind rock piles or islands. Singly or in pairs, they hang suspended, two fathoms down, fanning neither fin nor tail. Even a wayward crawfish cannot stir them. However, after five weeks of this repose, their scales accumulate a slimy overcoat, one sufficient to insulate them from winter's chill below the ice.

These conditions all but maroon Junnie. Oh, there are two or three days when he and his crew of six others will "clean out the seine hauls." Dragging weighted nets along the river bottoms, they pull out limbs, logs, and the like, clearing a flat area below where fish traditionally bunch in fall and winter. If a seine drapes across a branch or log or any large object, it creates exits below the wall of mesh for the hundred thousand or so pounds of fish penned there might, upon leaving, take a good part of the Putmans' winter profits with them.

Coating the seine with tar, which protects it from the water's corrosive effects, consumes another afternoon or two, as does the patching of broken mesh and re-stitching holes where panicked perch or buffalo were able to push through the previous spring. But, these labors completed, the crew must wait some weeks for the perch and buffalo to gather into small convoys and then glide into the backwaters where they will then bunch up in uncountable numbers.

There is always something to be done ashore ("Seems like I can't sit still for more than thirty pissin' seconds," complains seventy-two-year-old Dave Putman). About ten Putmans and friend Doug Griebel break up Big Dave and Thelma's sidewalk and pour a new one. Next week, a tree leans too closely to Junnie's house and down it comes, limb by limb, to fuel some of the south end's furnaces that winter. Big Dave might put the finishing touches on a johnboat he constructed, one modeled narrower than standard so that during spring he can skim between trees on flooded islands rather than circumnavigate them. "Saves on pissin' gas, you know," he says.

Then the third Sunday in October, Junnie and seven others assemble on a farmer friend's acres and decide on strategy for their upcoming hunts. Junnie, for years the best shot, will now beat the bushes for the first time since his early teens. Too many years of squinting at net markers into

water-refracted sunlight have compromised his sight. He even finds it difficult to line up an object ball at the far end of a pool table. "I got plenty in my time," he reassures a friend, "and there's still a few more in the old buck yet," he concludes, sighting down the barrel of an imaginary gun.

All seven of the crew gather in Junnie's market, sipping coffee, sitting in a wide semicircle as the all-weather radio station crackles in the background. Junnie strains for some time to make sense of it through the static and at last springs to his feet, shouting, "Let's get goin' 'fore it kicks up too much."

Six of them motor ahead in two boats while Junnie, nets and buckets piled aboard, follows alone. He, trying a shortcut, is delayed by low water. "Channel was eighteen feet last spring, but I didn't think the drought lowered it that much," he says, lifting his outboard halfway out of the foot-and-a-half-deep passageway.

Breaking through the slough, his perspective opens suddenly. Across four hundred feet of water, he sees a narrow, sandy beach stretched out beneath its hundred-foot-high dune. Coming closer now he discerns the crew, lined up dutifully ashore, ready to spring into action at Junnie's first words. No one likes to feel the sting of his reprimands ("Useless as tits on a boar!" he mutters of laggards, either just in or out of earshot, who fail to keep up with his frantic pace).

Keenly, Junnie appreciates the scene before him, cutting the motor some, hands over his eyes to shade the glint of

sunlit waves and glaring sands, considering who and what gear should go in which boat. Hunching forward, tensing, set to imprecate, command, suddenly his glance shoots upward. "Eight Canadians!" he exults, just as the scattered honkers, clearing the ridge, now fan into their familiar formation. And though it is perhaps his hundred thousandth sighting of them, "Eight Canadians!" is warbled jubilantly as if it were his first.

Five minutes later, one end of the seine is staked onshore while the rest of the net is piled into a boat. As the craft heads straight out into the water, Junnie lets out the net's first ninety yards as another crew member guides. Some thirty-five feet high, this first section of the seine is referred to as the bag (although it would drop straight down in deep water), for in shallow water of ten feet or less, pushed by current, it forms the pouch that will ultimately hold the fish.

Soon, out will tumble the remaining sixty yards called the lead line, which is only fifteen feet high and will guide fish to the bag. Carefully, Junnie spools it out, keeping the top cork (or top) line from twisting with the lead (short *e*; hereafter "led line" to distinguish between the two types of "lead" lines) or bottom line, allowing the net to form a straight wall. Any snarl creates a hole from which their catch might escape.

With some forty yards of lead remaining, Junnie barks out, "Up the bank!" and slowly the boat turns, forming a gentle arc. At last, all 150 yards of seine form a semicircle, nearly closing off the waters between shore and a nearby island. Then Junnie's boat joins another one a hundred yards upstream. Some forty feet apart, they describe ellipsoids, listing slightly to wake the water, then exaggerating their turns further. Slowly they circle at first, the motors only growling, but

shortly they gun them into a roar. Then two men in each boat raise plungers (such as are used to clear plumbing) in the air with an extra two feet of handle tied on and splash their rubber cups a foot below the waves. *Sploosh, boom, kaboom!* echoes up and down the cove, even above the wind, which has risen considerably.

Spaloosh! The rubber cups are pushed deeper. Shock waves are sent beneath the water, starting fish into motion. Closer and closer to the seine the boats move, describing ever smaller circles. However, the men see neither ripple nor thrash upon the surface, only wave upon wave, which their outboards wash southward. Drawing closer yet, they notice the net's cork bobbers bouncing. "There's something in there," someone yells.

One crew now lands, rushing through the sand to unstake and grab one end of the net, while the other crew rides the net's other end to shore. Some fifteen yards apart, the men of the two crews dig heels in and begin their tug of war. At first nothing budges, but as all seven arch their backs, the net's bag or pouch moves a bit. "Come on, perch!" yells Junnie's nephew Ricky.

"Here, perchie, perchie, perchie," says Doug Griebel as the circle collapses further and works protesting species along the wall to the bag or pouch. Yet all this tugging and jerking must be done with care, for if the led line and cork line twist, an opening may be created for the fish.

Though the bag now circumscribes this school, it is quiet. By the thousands, fish are silently pushing outward, but in vain. The bag's mesh, thicker and more tightly woven than the lead, resists, capable of holding ten times their number.

They can only poke their noses through the smaller holes and retreat, for if gilled they would be held in place and mutilated horribly by their stampeding neighbors.

All at once the waters heat into a boiling cauldron. Realizing their futility, the fish reverse themselves and thrash about the pen, the noise louder than a thousand mallards taxiing from a pond. Yet all this fury doesn't cheer a fisherman's hopes or guarantee a fattened wallet. Above the din, Ricky explains, "We had a fifty-thousand-pound haul last year and only ended up with ninety pounds of perch. The rest was shad [a small, silvery fish of no commercial value]. Spent half a day, four hours workin' 'em from the mash [mesh]; it was blowy like today, and only ended up feedin' the gulls and eagles."

Junnie, dip net in hand, wades atop the bag. Across it he sweeps an arc of ninety degrees through the water before hoisting some fifty pounds of fish. Into the boat now spill the fins and scales, twisting, bucking, spraying arcs of droplets ten feet high. Unmindful of the commotion, Ricky and his dad, Richie, Junnie's brother, sitting in one boat, separate the various species, tossing game fish back into the river.

Each new batch placed into the boat protests vigorously, thumping tub, plank, or bucket, some with a single slap, others with a hyped staccato. Junnie frowns at the source of all this bass accompaniment: "All the perch is two-, three-pounders, and Schafer [the market owner] mostly wants five-pounders and up."

Junnie's tenth load admits some new species to the boat hold. Back into the river go two "striper" (striped) bass and

an eight-pound dog-nosed sturgeon with its armored coat. Each of its scales ends in prickly cartilage and must be handled carefully. "They used to grow to a hundred and eighty pounds," says Richie. "When we was kids, everybody thought they was just a rough fish. Stack 'em up like cordwood, get 'em out the way, 'cause they'd wreak havoc on your nets. Today they're a delicacy. Shit, if they was legal you could get pret' near fo' dollar a pound."

And on the next load, a twelve-pound northern pike, a game fish, gets returned to the drink. "One for the pohliners," says Ricky, running together the words "pole" and "liners," a vaguely contemptuous term that commercial fishermen call sport fishermen. It is slightly less offensive than "flat assers," which is what more southerly tradesmen call their sporting cousins. Another local name for them is "Jimmy Cranes," also a nickname for the great blue heron. Why? Because like the large bird, says Junnie, "They just stand and stare at the water."

Richie turns up his nose at the pike. "Lotta people like 'em," he says, "I never did. They's too many bones. But I hear they serve 'em in some of the best restaurants, places like the Quad Cities, Chicago. But they breed like rats, you know; don't have any enemies. One day they'll eat up all the bass and crappie, and won't you hear the pohliners scream then!"

After a half hour, so many fish have been scooped from the bag that catching the rest, swimming more freely, is difficult for Junnie. The men of the crew reassemble ashore, and once more they tug at both ends of the seine until the bag confines the fish more densely, making them easier to scoop.

During their fifteen-minute break, most of the crew stretch out on the sand or back up against a twenty-foot log, munching on sandwiches. Junnie, pacing back and forth, sips from his thermos while his brother Dave, sitting atop the log, unwraps his first real nourishment of the day, a Snickers bar (one of these always occupies a place in the Putman lunch bucket; if the day overextends itself, it becomes a meal). "You don't ever see me eat too much, do you?" says Dave, grinning. During winter seine hauls, he has a Snickers bar midmorning, and at 1:00 P.M. he nibbles disinterestedly upon a bologna sandwich before discarding most of it. "Oh, I have a couple of big sit-down meals a week, eat real good, turkey with dressing, that kind of thing, but otherwise I don't bother with it much, you know."

The crew members arise and return to work. The first boat's hold fills up, and half its contents—buffalo—are transferred to a second while perch remain in the first. A pinkish residue the consistency of tomato juice and some three inches deep now sloshes upon the bottom just half-evacuated. Junnie explains, "That's the coat they built up the last few weeks, protectin' 'em from the cold. Lost most of it floppin' around, tryin' to jump free. Won't need it where they're goin' anyhow."

Some sixty yards of lead net, which direct fish to the main mesh, now stretch out along the beach. Perhaps the most frustrating labor involves removal of fish from it. The fish not only get caught in it but also tangle further when gusting winds (now up to thirty-five miles per hour) shake or fold the mesh. And all the while, in the blue glare above wheel some forty seagulls, squawking obsequiously or dive-bombing for some shad shaken loose.

The high winds allow the Putman crew only a single haul, for the boat holds, now both more than slightly half full, will be nearly swamped on the choppy return trip home. Besides, as Junnie explains after swooping up a last beached buffalo, "Perch is the first ones to lay up. They ain't as tough as buffalo or carp. And the big ones [perch] come in after the little ones, which is what we got today, 'bout three thousand pounds worth. But we'll be back in about ten days for their daddies."

But for now, the Putman crew must be content with about 120 dollars each for the morning's work, pocket change compared to what might be earned beyond the Christmas holidays. During late December on nights the wind shuts down, the air becomes forbiddingly cold, then ice begins to form in the backwaters, eventually crusting thick enough to hold a fisherman's weight. Then he will endure the lash of subarctic blasts and ignore the three-week spells of fishless seines ("Not even enough pissin' fish in there to pay for gas!") on the off chance that one day a quarter of a million pounds of drum and buffalo will nestle in the mesh.

A catch like this, supplied teasingly to keep prices up, can make their whole season, while two such hauls may offset a year of underfished nets. "Best time of year; that's when commercial fishin's fun!" concludes Junnie, without showing any trace of a shiver.

16

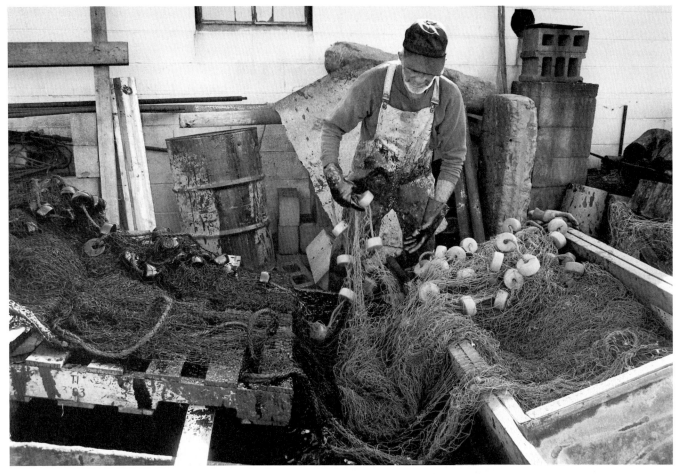

Junnie Putman tarring his 150-yard seine behind his house in Bellevue, Iowa, early fall

We had a relative living 'round Galena in 1860. Only his name
was Putnam. Clarence Putnam. Got drunk as a goat one day, they said,
went down to the draft board and enlisted for the war.

 But when he woke up next morning, cold sober, he thought better of it.
Crossed the river near Bellevue and changed his name to Putman. Switched
them two letters. And that's how we spelled it ever since.

 —BIG DAVE PUTMAN

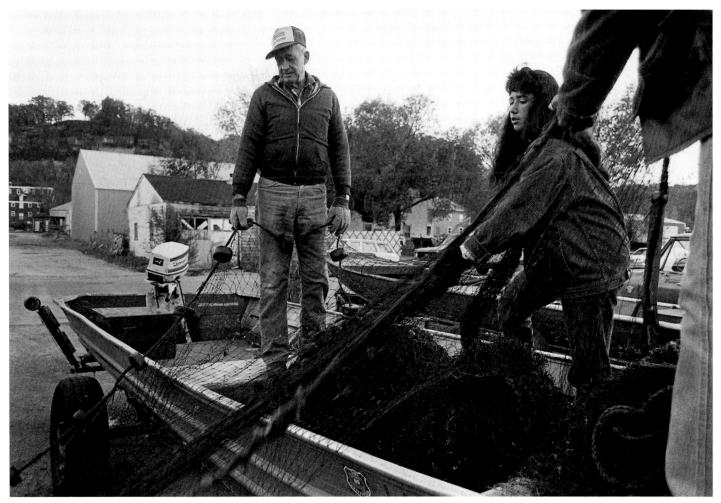

Yolanda Ciulla (later Griebel) and Richie Putman untangling seine behind Junnie's market

She pulls her weight as good as some of the men; better than one or two.
—RICHIE PUTMAN

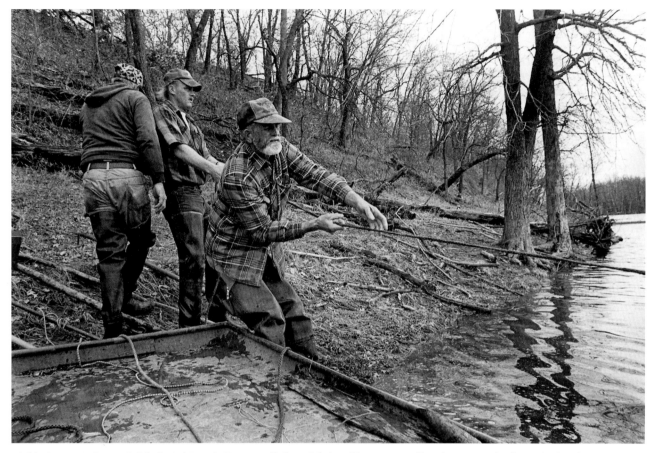

Richie Putman, Doug Griebel, and Junnie Putman *(left to right)* pulling on a sea line (rope attached to seine) to bring in four thousand pounds of perch and buffalo in early spring

None of them young kids they hire ever come back a second season. Nary a one. They all hurt themselves out there. Mark, he pulled his nuts out 'bout a month ago and just come back again. Then yesterday him and Jerry's hustlin' up those 120-pound boxes, fifteen thousand pounds worth. "Work steady, but take your time," Dad told 'em. But they don't listen.
 —STEVE PUTMAN *(Big Dave's son)*

Dad's seventy-three now, but you wouldn't want to tangle with the old bull, his brothers neither. No kiddin'. 'Cause as far as liftin' goes, don't matter how heavy or what size—might be a box of fish, a boulder, big cast-iron stove—they wrap their arms around it, straighten up, you know that object's comin' off the ground.
—STEVE PUTMAN

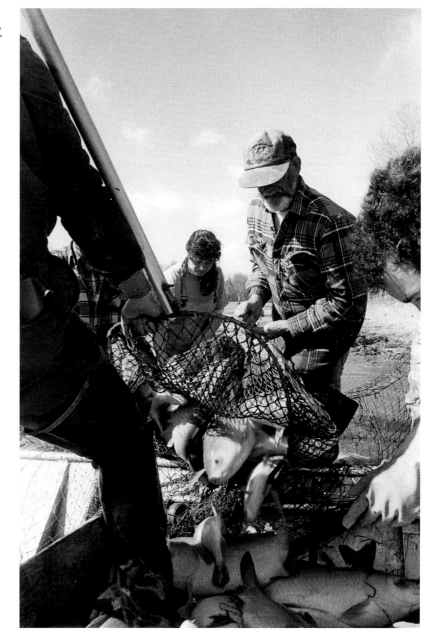

Junnie placing drum and buffalo from seine into the boat with a dip net on the Maquoketa River

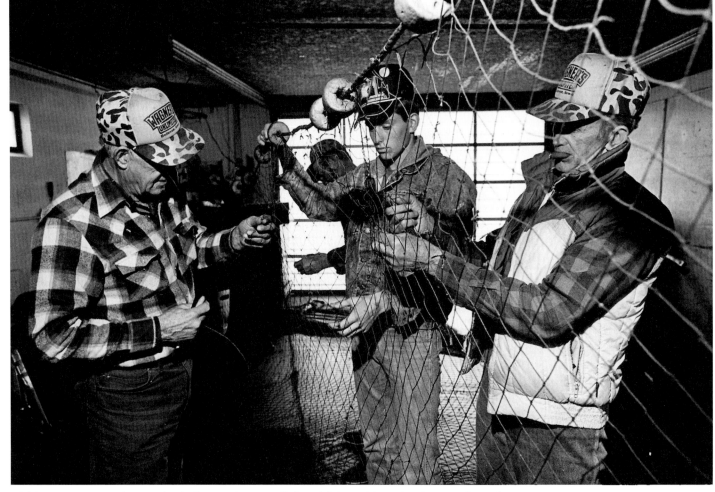

Richie Putman, Darryl Meyer, and Big Dave Putman *(left to right)* patching seine in Junnie's market

Look what happened to Mike last week. Lost his airboat out by
Sabula. Broke through in back, you know, where the motor and all
the weight is. He run up front as the bow come out of the water.
Just like climbin' stairs, he said. Lucky to get out at the last second.
And there she sits in eighty feet of water.

—RICHIE PUTMAN

A gang of us used to get together and dress each other's fish. Nothing more than a three-day drunk is what it was. And after that, the fighting started. Why, didn't take much to set it off: an argument about who caught the biggest fish or one fellow accuse another of settin' nets too close to his.

Yes sir, soon as they gutted the last carp or catfish, they'd drop their knives, and then the fists would fly. Oh, they had some jim-dandies. My mother yelled at 'em, they made such a mess, but didn't do no good. One time, I remember when they was guttin' out the last four hundred pounds, she snuck out to the shed where they kept the wine and poured a quart of coating oil into their jug. A whole quart! That's what they used for constipation. And Jesus Christ! You never seen so many goddamn commercial fishermen runnin' around in circles, bangin' on the outhouse door or dropping their pants, if they couldn't make it, in one shittin' time in all your life!

—VINNIE PUTMAN *(Junnie's cousin)*

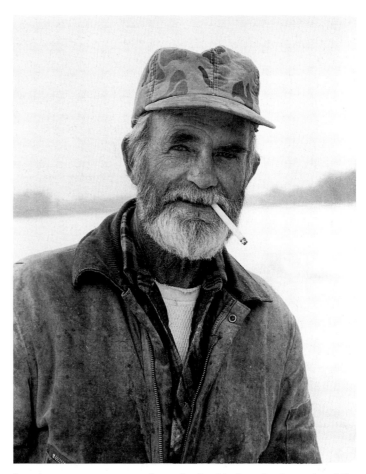

21

Junnie near open water on last seine haul before the freeze, late fall

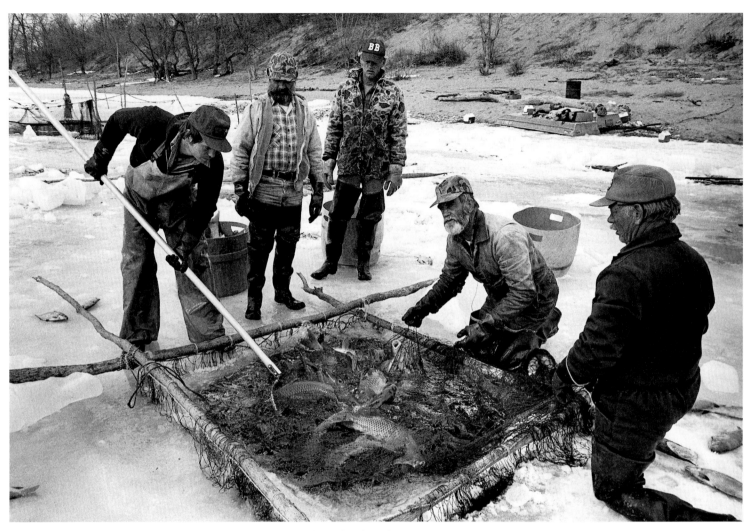

Putman crew members take small buffalo from a live hole where they have been separated
from fish in a larger seine at the Proving Grounds near Savanna, Illinois.

3 Seine, Below Ice

Almost every month, some dire report tells of commercial saltwater fisheries. In Nova Scotia's coastal towns, unemployment reaches fifty percent because cod and flounder, once so thick as to impede sailing vessels' progress, have all but disappeared. Farther south, the government closes the Georges Banks' once generous fisheries since many species there near extinction. In warmer oceans, too, coral reefs, home of many food fish, are either disrupted by great trawling nets or corroded by pollution that eats into their castle-like structures.

Inland, the Mississippi River situation differs: although fish numbers are down somewhat, a commercial fisherman who works diligently and is willing to endure subarctic windchills may pen in his underwater seine as much as three hundred thousand pounds of various species.

Sixty yards offshore, below a two-hundred-foot wooded hillside, the Putman crew of seven trudges sixty yards out onto the slough ice. There, they saw a four-foot-square "put-in hole" through the thirteen-inch-thick crust. Next, the four sections—broken down for storage purposes—of a sixty-foot 4" x 4" lining bar are nailed together and attached to the seine's bag end.

Junnie places this pole into the put-in hole and shoves its entire length toward shore. Another hole is drilled at the bar's farthest reach, where it is taken hold of and shoved toward shore again, thus introducing the first twenty yards of seine below the ice. By this method, they advance the net nearly all the way to shore. There, in about two and a half feet of water, they cut another opening, the manhole, some eight feet by fourteen feet. In this they hope to capture a large school of fish.

But that is hours away. For the present, the men return to the put-in hole where they re-affix the remaining ninety yards of net to the lining bar and feed it below the ice once more, this time pointed west, toward a distant island. By around noon it is reached, successfully closing off the slough mouth.

Another preliminary operation awaits them. At the end of this 150-yard seine is a rope of similar length, called the sea line. The crew members tie the lining bar to it, and into the last hole, by the island, it is shoved. For the next half hour they work it back to shore, sixty feet at a time. It meanders obliquely, hole after hole, curling at last one hundred yards upriver from the manhole, some twenty yards out from shore. There, they lift its sopping end from the water and coil some ten yards of it upon the ice, ready for pulling in a few hours.

After a hurried lunch, Junnie's crew sets off for a spot five-eighths of a mile down the slough. From there, with a power auger, one of them drills six holes some twelve yards apart.

Next, each member pounds the open water with a plunger. "This is the most boring part of commercial fishing," says Richie Putman of the two-minute process. "And you gotta make sure you push it a foot below the surface."

Fifty yards ahead, another six cylinders are drilled by Jimmy Budde, Junnie's twenty-year-old nephew, and the crew advances to pound and pound again. It will take around three hours and twenty-five different operations to drive whatever species lurk beneath the ice into the waiting net. No wonder disappointment runs deep when fishermen come upon empty mesh. In the winter of 1989, the day-long operation yielded nothing over a three-week period.

Although it is less than twenty degrees, the men are comfortable in the breezeless air, pocketed in part by the dunes. The previous week, gusts had swept over them, plummeting windchills to forty degrees below zero.

By 3:00 P.M., when they drive close to the manhole, Junnie runs ahead to inspect the net there and, noting its movement, raises his arm triumphantly. Assured the net is bulging, four of the crew pull on the sea line. Skipping, sliding on the slick ice, occasionally gaining traction on a patch of crusty snow, the crew gains ground. Across the slough, the seine begins to drag below the ice. It curls and curls toward and near shore (and the manhole) as all tug mightily. Junnie dons chest-high waders and jumps into the manhole's icy waters. "It's cold at first, but after fifteen minutes you don't think about it." By this time, everyone else stands ashore and is pulling the seine through the manhole.

Standing in the cold mud, amid the first arriving fins and scales, Junnie performs the Mississippi River commercial fisherman's most delicate and critical operation. While the

cork line whizzes by him in the air, the led line of the net drags along the bottom. Carefully, he keeps pressure with his foot upon it, but not too forcefully (which would prevent the men ashore from pulling). If he allows a hole to develop, or worse, the line to slip completely off his foot, it would fly up and the whole catch might swim back into the slough. As Eddie Putman will say that evening in Junnie's market, "You ever been out to a hog farm? Well, if there's a hole under the fence, one of 'em sees it and squeezes out; and if one goes, all the rest follows. It's like a stampede. Same thing with them fish. Oh, you betcha!

"Now some years back," Eddie continues, "Junnie was laid up real bad with the flu or something, and they had someone else work the led line, someone who didn't have Junnie's experience. I guess you know what happened. They had about a hundred thousand pound of buffalo penned up. The fellow didn't guide it right. By [the] time they got her sealed off, there was only about ten thousand pound left inside. Yeah, you could say the rest of the crew was pretty disappointed."

Carefully, Junnie treads upon the led line, sliding his foot forward one step, two, then drawing it back, almost like gliding upon a dance floor. The buffalo now swish sluggishly around him, some pushing halfheartedly on the nets. With the school now penned in (later figured at 140,000 pounds of mostly buffalo), Junnie hops out of the manhole and onto the ice, where the others dig several small holes. Through these they reach down and grab hold of a small section of the cork line and stake it to the ice. Now fish can neither burrow under the weighted led line nor sink the lighter cork line to swim over it.

The crew returns the next morning. Junnie slides an aluminum rowboat halfway into the open water. Balancing

himself precariously, he waves a long-poled dip net into the pool's crowded numbers, catching two, three, four fish, arcing them back onto the ice. There, Little Dave Putman (one of Big Dave's sons), Ricky Putman, Richie Putman, and Doug Griebel separate them: jumbo buffalo of six pounds or more into buckets, smaller ones back into the pond for now. Game fish such as a stray northern pike and a half dozen wayward striped bass are tossed into a nearby hole, free to languish until spring. By 2:00 P.M., some seven thousand pounds of buffalo are loaded onto the three pickup trucks, and the caravan sets out for the market in Fulton, Illinois.

Only a fraction of the fish caught is transported at one time. A larger haul might flood the market and close it down, which is what happened the previous year. When the Putmans netted forty thousand pounds then, they found the market already closed and had to wait two weeks, by which time the fish had died. The "live market" gone, they eventually had to sell at half price.

For several days, the Putmans portion out their catch. Then on the tenth day, they get a call from a buyer in Chicago who wants nearly thirty thousand pounds. With just a few thousand pounds of fish penned up after the sale, the Putmans think of making another set elsewhere.

The Putman crew assembles in Junnie's market the next morning. They form a semicircle, peeling off coffee cup lids and sipping the hot liquid. The previous night, it had been decided that they would set a second seine in a slough north of Bellevue where it was hoped they would drive more profitable perch. A good catch there might turn a mediocre season into a very good one. But they would have to act quickly; the next warm days would make the ice too thin to walk on.

In the spring, when the ice begins to melt, seining conditions can get tricky. Once, when the crew was on the mostly open water of the wooded Maquoketa River, nine miles south of Bellevue, someone had yelled, "Ice!" And a quarter mile downstream, a sheet three hundred yards long and eighty yards across had loomed into view. Within two minutes it had bobbed over their mesh, caught upon its floats. The crew had flown into action: Junnie ran his boat behind the block of ice and pushed, while Big Dave, ahead, sank a grab hook into a soft spot and tugged. Within five minutes, the seine was free and the ice floe continued its slide, unhindered, to the Mississippi.

As everyone stares into space and Junnie pokes at his nets and other gear, Richie stomps in. "Why we goin' above the dam? There ain't no goddamn perch in that slough!"

"We drove everywhere else," says Junnie quickly.

"If you ask me, I'd let all them buffalo you got penned up go."

"There's four thousand pounds of fish in them nets, buddy," says Junnie.

"Yeah, *buddy!*" mimics Jimmy Budde.

"So what," says Richie, "you only gettin' eighteen cents a pound. I say cut the nets and let the sons a bitches out, catch 'em next year."

"There's too many fish on the market, Richie. We gotta hold 'em 'til the price goes up. Now get your life jacket. That ice ain't too thick yet."

But the phone rings and the call Junnie gets changes everything. On the other end is Vinnie, his cousin from Clinton,

Iowa, forty miles south. The two men talk some minutes, then Junnie hangs up, announcing, "Tugboat hit the Clinton locks at four o'clock this morning pushin' three barges [which will break up the ice]. She should get here by dinner-time. I'll call Mike [Schafer] and see what he'll give us for the [penned up] buffalo."

The road dips and rises for twenty miles, sided alternately by farmland and forest on the way to Savanna, Illinois, the closest town to the Putman seine. Near the town of Green Island (pop. 40), a hawk jumps his fence post and floats over a field of corn stubble. "They're gettin' thicker back in the woods," Junnie says. "Lotta owls, too. Only hear 'em at night when I'm runnin' my traps. Then and right before a rain. Oooh yeah, they hoot like hell."

Next he nods toward a low wooded area. "Lotta turkey in there. Ricky was layin' for 'em last fall just by that rise. One come out of the brush and he just snugged the butt against his shoulder to get a better shot, already had the gun up, and the bird disappeared. 'Jesus! Where'd he go?' Next day he shot a twenty-pounder, though. Blew his head clean off. You can't aim for the body. They got too much protectin' 'em. But they're fast. Outrun a deer. Oooh yeah. Over two hundred yards, they eat up more ground than a buck."

All morning the men of the Putman crew harvest buffalo from their seine, dumping fish into one tub after another and loading them onto their pickups. By 2:00 P.M., the net is empty and the three-truck caravan sets out for market, axles sagging under the weight. Still a mile north of Savanna, they pass below a towering palisade scooped out of the earth by

ten-thousand-year-old glaciers and stop. Hugging the narrow shoulder between road and ice, they peer across the river. "There she is, the son of a bitch," says Ricky. And far out in the channel, a tugboat announces its presence, shearing off a flatbed-sized chunk of ice, the noise echoing a mile down river. "Sounds like a cannon," Ricky continues.

"Worse than that," says his father, "boom like a steady roll of thunder when she hits it right."

"Son of a bitch!" exclaims Ricky.

Back in the truck, a worker standing in for a sick crew member wonders why a narrow lane broken midriver stops fishing operations three hundred yards closer to shore. Junnie patiently explains, "When that tugboat chews off a piece, they kick it underneath the surface, skid it a quarter mile or more. And don't walk above that area. Nooo, when barges pass, commercial fishin's done. Only reason we'll clear out our nets tomorrow's 'cause we set behind an island."

That night the crew gathers in Junnie's market. Others drop by: Roger Keil, a farmer and an old friend, and Billy Reistroffer, Junnie's nephew. First the day's events are rehashed, and then older topics arise. Someone says while crossing Catfish Slough the previous week, testing the ice ahead with his spud, it gave way so easily the metal rod slipped from his hand and sank into fifty feet of water.

With country music playing in the background, one story-teller after another holds forth. They recount while seated, spreading arms to show how big a fish or wingspan was, or jump up to more actively spin a yarn. Junnie often raises his hand up and then plummets it floorward, illustrating how a duck "lights on a pool," and it is easy to envision "woodie," or a mallard, falling from the sky, banking into a wind current, skating crazily above the water, yielding at last to gravity, and plopping on the surface.

With more Old Milwaukee in his gut, spiked with an occasional highball or nip of apricot brandy to cut hoarseness, Junnie grows testier, more impatient with those less aware of local woodlore. After rattling off a list of federal and state workers' misconceptions about it, he concludes, "You learn animal habits observin' nature, not readin' books or studyin'. I know lot more 'bout fish than any fuckin' biologist."

Later, Junnie remembers a time when everyone was honest, then relates a story of how fellow Iowans had stolen from his traps and how he had remedied it in 1984 when his eyesight was better. "I had a real good spot; if a mink come within twenty miles, he'd have to pass it. Took seven or eight a year there, but now I wasn't gettin' none. Plenty indication: ground tore up where they struggled, hair left on the iron; so I know someone's stealin'.

"I started come 'round different times, tryin' to catch 'im, but it wasn't no good. So one mornin' I got up at two o'clock and started out. Put down a blanket behind some bushes about fifty yards from where they was set and sipped my coffee, waitin'. First day I sat there six hours. Second day, the same. Third, just as it's gettin' light, I hear a twig snap an' I'm pretty sure it's him. Eased over on my belly, snugged up the rifle, and sure enough, the bushes part and out he steps. Oooh, he was careful! Looked up the bank, down the bank, out in the slough, even right where I was layin'. Thought for a second he saw me.

"Now he goes straight for a trap, bends over, and takes a pelt. Then he goes to another. By that time, I scoped 'im. For a second didn't know whether to blow his head off or ricochet the trap. He looked 'round and stooped again . . .

"*BOOM!* I kicked it out his hand. 'Hold it right there!' I jumped up, walked over, took out my pistol, and pushed it right in his face. 'I coulda killed you a second ago or do it right now and no one be the wiser,' I says. 'Got your grave dug way back in the slough and nobody find you in a thousand years. Let you go this time, but don't show up 'round here again.' Never seen 'im after that, not squirrel huntin' or pickin' up acorns."

Doug Griebel comes over and tells about Junnie's trapping prowess.

"Not much I can teach you, Doug," Junnie states.

"On land maybe," says Doug. "But if I could go out on the river with you just one season, pick up some of your expertise, then I might begin to call myself a trapper."

"No need comin' out with me. You know them hills good enough to make out," Junnie insists.

But Doug persists in his praise. "This man probably knows more about river trappin' than anybody in the state of Iowa. No, I'll say Iowa, Illinois, Wisconsin . . ."

"Now wait a minute, Doug, you don't know everybody in them areas."

"No, but you're the best there is. Will you let me come out with you this year?"

"I don't know how much longer I'm gonna trap, Doug. It's thinnin' out and too many's stealing sets, pelts, traps and all. Nope, day of the trapper and the fisherman's almost done."

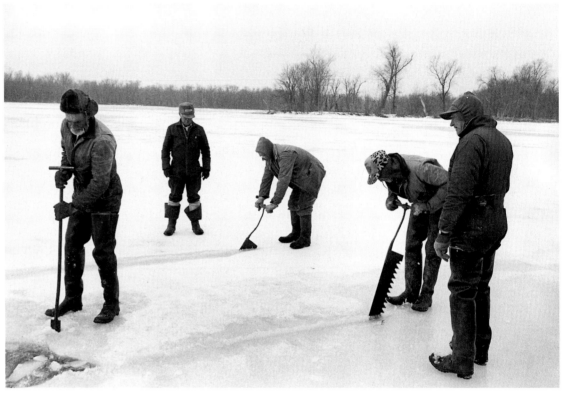

Junnie Putman *(far left)* and others cutting out a manhole where they will push seine underneath the ice by the Proving Grounds

As for our family history, supposedly Great-Grandpa Jake got drunk one night, went walkin' by the button factory, fell in, and drowned. But last month Eddie found a Bible in the attic and inside was an old newspaper clipping from around the year 1880. Said someone discovered Jake Putman's body below the Bellevue Dam and that his hands was tied behind his back, a brick or stone tied 'round his ankles, and two bullet holes in the back of his head.

And then it said soon afterward, a judge declared that Jake had killed himself. How can that be? How can somebody tie a cord around theirself, bricks, too, then shoot theirself in the head? It don't add up. Although it happened eighty years ago, it's sure got us all upset. Not losin' sleep, but sure, we'd like to know what really happened.

—PEGGY HAYES

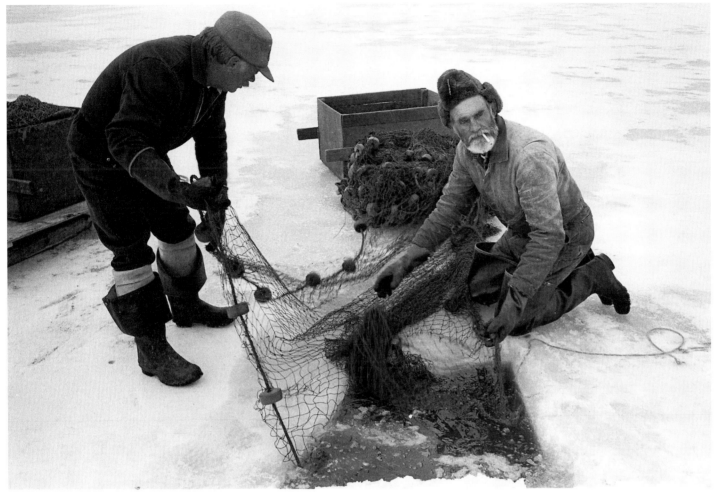

Junnie *(right)* and Cliff Ennis pushing seine under the ice, keeping the cork line *(left)* and led line separate

Sometimes a mound of snow'll drift atop thin ice and insulate a spot. So when she freezes up all around, up to a foot or more, it only crusts a quarter inch below them crystals. And then another blow come through, dust 'em off, and no one know the difference.
—JUNNIE PUTMAN

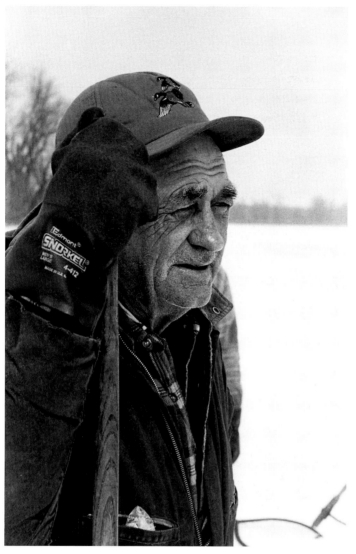

Richie Putman resting on a plunger before splashing water to drive fish toward the seine

Last year, a trapper fell through. He was goin' to a wedding, running late, and shortcutted 'cross an untested stretch. When they found the body next spring, his fingernails was gone. He tore 'em out clawin' at the ice, thrashin' around inside that hole. Nope, none of 'em was left. That force of life is pretty strong, but . . .

—JUNNIE PUTMAN

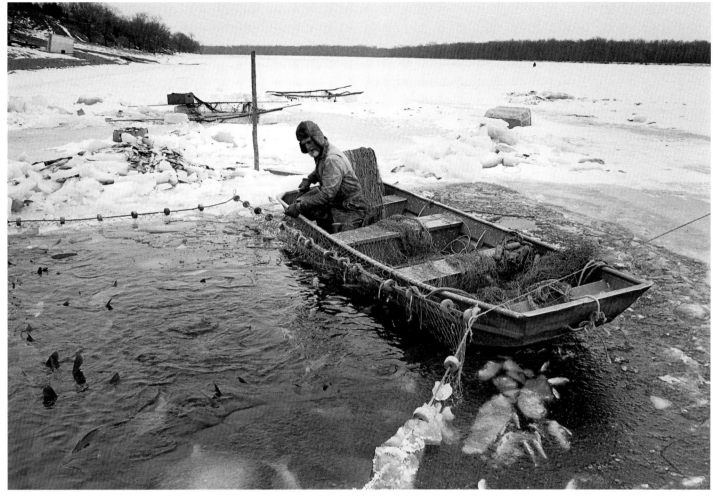

Junnie in windchill of forty degrees below zero tightening the net to facilitate the removal of fish

One day the windchill was eighty-six below. We'd scoop a fish from the manhole, and by the time we'd get him to the truck, fifteen feet away, he'd be froze solid. Hit someone over the head with it, you'd knock him out.

—RICKY PUTMAN

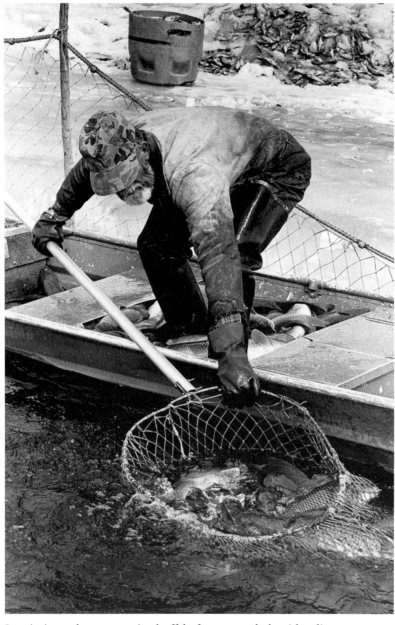

32

A weak mind, a strong back, a wet ass, and a hungry gut.
—JUNNIE PUTMAN (*talking about Mississippi River commercial fishermen*)

Junnie, in rowboat, removing buffalo from a manhole with a dip net

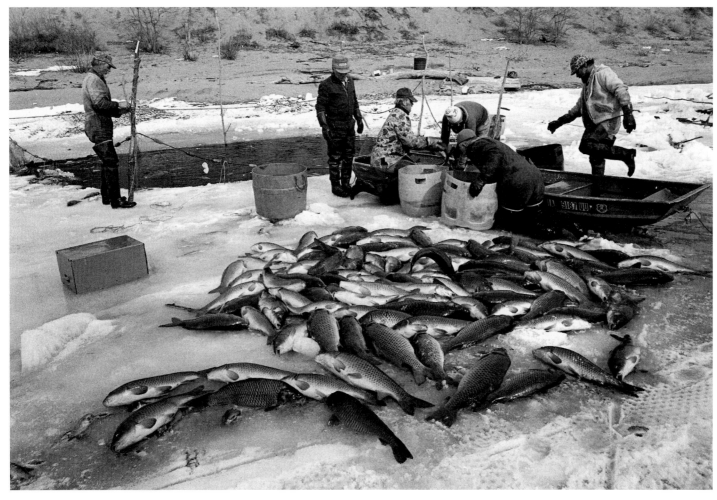

The Putman crew separating buffalo by size into fish tubs, a manhole in the background

I used to work with Junnie when we first got married. We'd work all morning, run into the house and make bologna sandwiches, then jump into the boat, stay out 'til six o'clock. Went on seine hauls in wintertime, just like the crew today. But you wouldn't get me standin' in any of them ice-cold manholes. No way in hell I'd do that!

—MARY PUTMAN

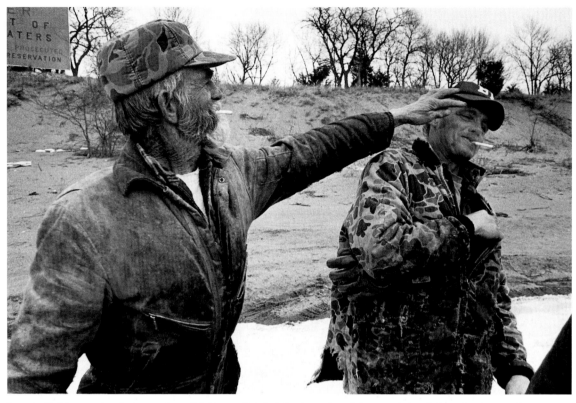

Junnie *(left)* engaging in horseplay with Doug Griebel during a break from seining below the ice on the Proving Grounds

I get along with most of 'em. Hell! I like a lot of 'em. But no one wants to get on the wrong side of a Putman, rough bunch as they are. But if one of 'em likes you, if you earn their trust and respect, which don't happen overnight, then you got a friend for life.

And when that one takes to you, then all the rest accept you, too, the whole family—it's like you been adopted.

—CLIFF ENNIS *(neighbor of Putmans and member of crew)*

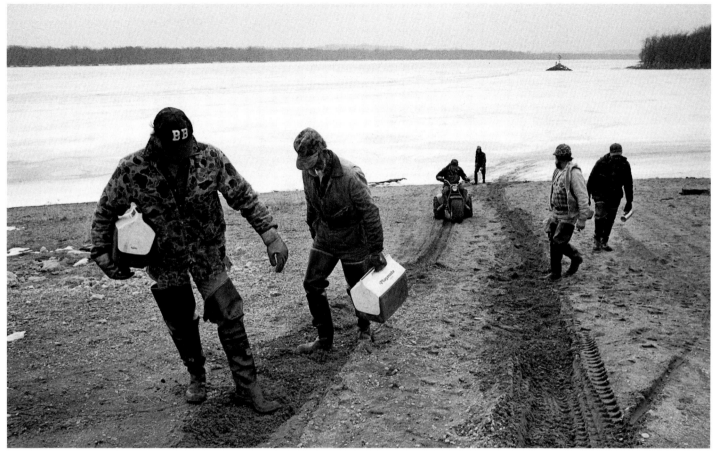

The Putman crew climbing up the hill at the conclusion of a day of seining by the Proving Grounds

Lot of 'em think you just tuck a lunch bucket under your arm and run to work. Don't go that way. There's patchin' nets, tarrin' 'em, cuttin' twine and retyin' it (s'posed to be seven inches between knots). Always somethin' to do off the river. No, this ain't no Monday through Friday, nine to five job.

—JUNNIE PUTMAN

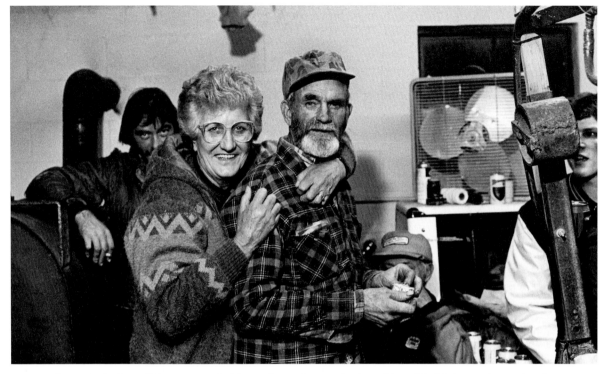

Mary and Junnie during a light moment in his market at the conclusion of Junnie's fishing and trapping day

Eddie and I was fishin' on this lake out by Maquoketa some years back. Nothin' but buffalo, at least that was all you was supposed to take. Well, one day he caught a real nice catfish, about six or seven pounds. I says, "Eddie, let's keep this one." He says, "You want me to lose my license?" I says, "How long has it been since we seen a game warden or anybody from the DNR? Months, I bet."

Now we're pullin' into the bank, and all of sudden about six or seven of 'em come out of the weeds. They musta been havin' a convention or somethin'. "Let's see what you got in the boat!" Well, I jump out with the box we'd set him [the catfish] in and flip it over. Then I sit down atop it. And all the while they was goin' through our holds, I was thinkin' if he sticks me through a crack with his spine, no matter how much it hurt I wasn't gonna say nothin'. Well, he didn't and neither did I.

—ANGIE PUTMAN (*Eddie's wife*)

All the old river rats is gone. Ain't seen one in twenty years. Like old "Toot" Waite, who lived on one of the islands. Grew his own vegetables, caught all the fish he wanted, cooked 'em up.

When his fryin' pan larded up, he'd hold it over a fire and let the fat run off. Cups so stained with grounds he could only pour three teaspoons in 'em. Offered me some once. I said, "Thanks, I got my own thermos."

—JUNNIE PUTMAN

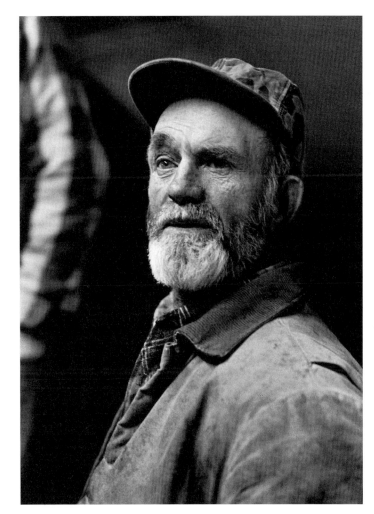

Junnie reflecting during a quiet moment in his market

Willard Kress brings carp and buffalo on a trammel net set north of Oquawka, Illinois, 125 miles south of the Putmans.

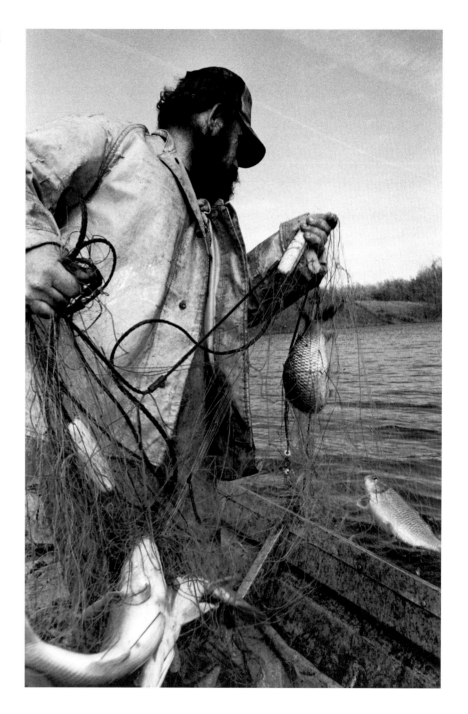

4 Trammel Nets

Junnie's onetime brother-in-law and partner Orville Steines—six foot two and solidly built but so crippled with gout he can walk only with a cane—relates a story. "One winter, just before freeze up, me 'n June netted five hundred pounds of buffalo back in the slough. Well, just as we're takin' in our gear, 'long come a couple fishermen. 'No one wants no buffalo,' they say, 'only perch.' That's how she goes sometimes. So now we run into shore and empty out the boat, put all our buffalo up on the bank. Figure we give the crows and eagles a good feed.

"Well, about a week later," Orville continues, expectorating a stream of tobacco juice toward the corn beyond his backyard, "market calls up and asks if we got any buffalo. We didn't have none, no, but we figure since the weather turned warm the last day, there'd still be some open water. So we run out to where we done good last time.

"Just as Junnie's 'bout to let out our net, I holler, 'Wait a minute!'

"'What's the matter, Orville?' he says.

"I says, 'Ain't those the buffalo we caught last week?'

"He says, 'Yeah, I think they is.'

"So I run into the bank, jump out, and go over to 'em. They didn't look too bad. See, those first two nights after we left 'em, it got pretty cold. Then I get closer and see the crows pecked out all their eyes. Didn't touch nothin' else, though, 'cause it froze solid. So right there we cut the heads off, run 'em into market, and got our thirty cents a pound."

Yes, there are stories such as these that go along with trammel netting. But use of this fine mesh, virtually invisible below the waves, is so simple that it all but defies constructing a day of narrative.

First, it requires no bait and, thus, no gathering or gaffing of worm or crustacean nor cramming foodstuffs into bags. Upkeep is minimal as well. Unlike the thick nylon mesh of hoop net or seine, which must be tarred annually, the trammel net's thinner nylon twine somehow resists the Mississippi's corrosiveness for several seasons without care. It also handles easily: a man of modest strength can lift its length coiled inside a box and carry it aboard. Finally, its operation taxes the commercial fisherman less than any other gear.

Mid-fall or mid-spring, Junnie lets out its hundred-yard length across a slough or creek or by rocky outcroppings in the Mississippi, careful to keep cork and led lines parallel, not twisted. Then, as in seining, he runs off a distance and pounds the water with a plunger, "driving" fish to net.

(Other fishermen accomplish this by striking a railroad tie plate placed upon the metal bow of their craft.)

After waiting two minutes, allowing fish to work into the mesh, listening to breezes rustle the few stubborn leaves that winter couldn't shake loose from boughs, Junnie goes to the net. Its construction assures him of a high percentage of capture. Instead of one wall of mesh, three separate six-foot-high walls, right behind each other, hang in the water. Passing easily through the first sixteen-inch mesh, the jumbo carp or buffalo will work only halfway through the second three-inch mesh wall. When he pushes this barrier into the third—another sixteen-inch one—he tumbles into its extra webbing, which forms a pouch, called the pocket. Up to one hundred pounds of fish can be taken in one of these, and several might form along the net's length.

After pulling the net aboard, Junnie picks through the mesh, shoving one buffalo through, pulling another back, untying, shaking, slacking, unworking, swearing at snags. Within ten minutes, he has removed all fish and knots and may let out his net once more. Some fishermen bring along a half dozen trammel nets and, after fishing one, simply deposit its whole load—fish, twigs, leaves, and mesh—on the boat's bottom until brought to dock. Junnie, however, brooks no such rough housekeeping, tossing all catch below in the hold.

Some of Junnie's competitors "dead set" nets, letting them collect fish over one night, even two, if the water has chilled enough to refrigerate capture.

But even this least complicated of the fishing operations requires a good deal of skill and knowledge, as Junnie relates with this trammel netting story. "Can't rush commercial fishin'. One time, soon as me 'n Orville come out, it clouded over, cooled off the water. We tried a drive, but only got a couple carp because the fish moved to the channel where it's warm (can't budge 'em from the bottom there). So we lay down and dozed a couple hours, until the sun come out to warm it up inshore. And then we run one set and filled the boat, both holds.

"Now all that mornin' we hear another crew from Clinton thrashin' around the backwater. They only netted eighty pounds. We seen 'em at Schafer's later on. They said, 'How did you guys catch all them fish?' I snuck a look at Orville, said, 'Little bit of hard work, a lot of luck.'"

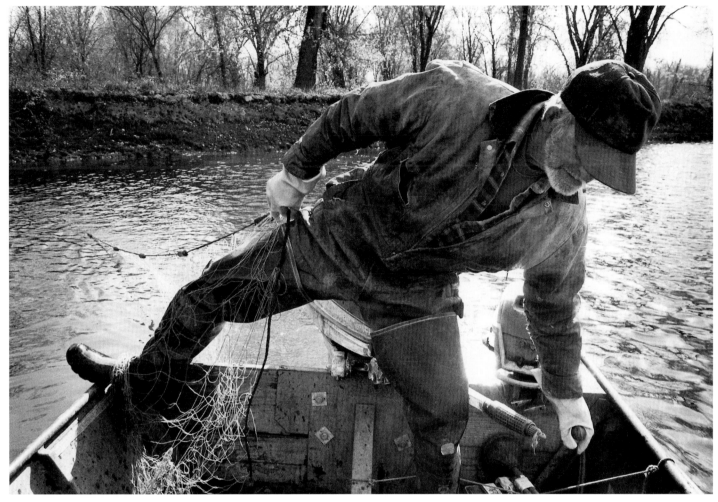

Junnie Putman letting out a trammel net across a slough, careful to keep cork and led lines separate

When Junnie and I got married, we had twelve cents in our pockets. Two days later, when he hit Kennedy Slough, we had twelve hundred dollars. But that first morning, there was only one potato in the house. So we had French fries and jelly beans, licorice jelly beans left over from our reception. That was our wedding breakfast. That weekend, Junnie took me to Savanna for steaks. And that's the way he's been ever since: up and down, good times and bad.

—MARY PUTMAN

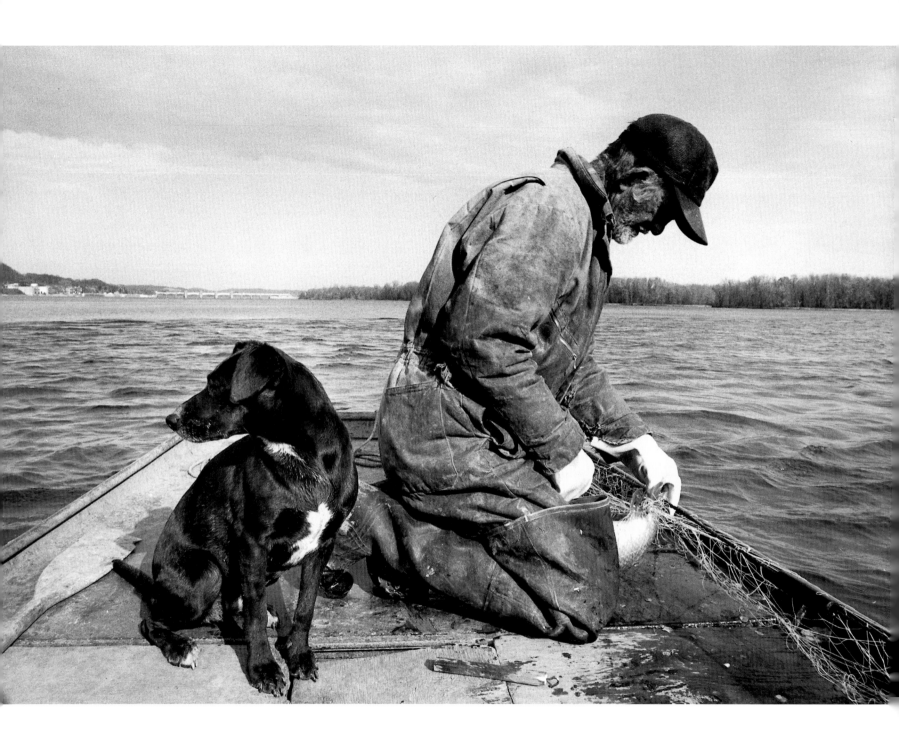

One night he didn't come home 'til after eight o'clock. I says, "Why didn't you tell me you was gonna be late, I been heatin' your dinner for two hours now." Him and his partner had stopped for highballs, see.

Well, Junnie reached down and drew that revolver he uses on animals that the traps don't kill right away. "Goddamn it, Mary," he says, "me 'n Orville been breakin' through the ice, liftin' sets [traps] since six o'clock this morning." Then he put four bullets in the clock, one of our wedding presents.

No need to say nothin' after that.

—MARY PUTMAN

Junnie, with his dog Queenie, removing a fish from his trammel net set near a rocky outcropping on the Mississippi River

Ross DeSherlia, eighty-six years old in 1990, makes a hoop net for other commercial fishermen outside his Grafton, Illinois, home, about three hundred miles south of the Putmans.

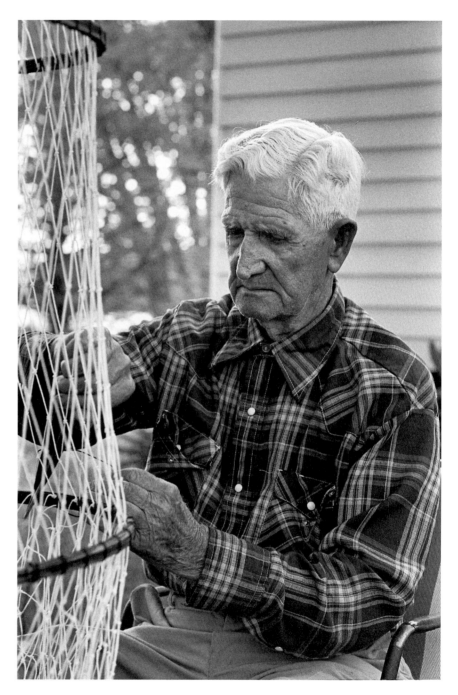

5　Hoop Nets, Catfish, and Buffalo

Hardly anyone else is stirring at 5:00 A.M. when Junnie leaves his house, coffee cup in hand, and opens the door to his market. Before tugging on his waders, he clicks on the radio to an all-weather station. "... high around seventy, winds of ten miles per hour, humidity ..."

"Yeah, Queenie, we're going to the river today!" he tells his little black dog who yaps at him. "Sit down, girl!" he growls. After a few contemplative sips of coffee, he rises, striding next door to confer with Big Dave and Little Dave, who will also fish that day. The latter moves obediently to each of his father's commands, such as, "Put that bucket in the bottom of the boat," and asks in a humble if not obsequious voice, "You wanna take the extra motor along, Dad?"

This contrasts with the beer-and-whiskey-soaked snarls he had muttered the previous night at Junnie's market. In the fall of 1990, when challenged by three men outside the Lock and Dam Number Twelve Tavern, Little Dave had hoisted the largest—around 240 pounds—by his coat and pitched him through a plate glass window.

Fifteen minutes later, almost as soon as Junnie backs his boat into the river, he brakes it and returns home, an event unusual enough to bring the game warden scooting dockward. Learning the reason for Junnie's backtracking, he remarks, "That's the first time in twelve years he's ever forgotten a piece of gear."

What had caused his forgetfulness? Was he still distracted by the previous Sunday's events, when, after a day of drinking during a family reunion, he and Mary had argued bitterly at Lock and Dam Number Twelve? She had taken a swing at him, but he had ducked, and the blow had caught nephew Jimmy Budde on the temple, knocking him off his bar stool and starting a melee. Or were his thoughts racing ahead to a medical appointment in Iowa City next week? There, his skin cancer (which had already eaten away part of his nose and ear, both surgically yet imperfectly replaced) must be treated. Perhaps the next surgical scraping ("It sounds like a rat chewing on a board") would cut so deeply as to keep him off the river forever. Junnie yanks the starter cord, and the engine roars. As the boat jumps forward and cuts through the fog, he leaves those considerations upon the diminishing shoreline.

Once around an island, Junnie makes straight for the opposite shore. As he approaches a seemingly unbroken line of trees, a channel opens up, and through it Junnie sluices his eighteen-foot johnboat. After bouncing through fifty yards of turbulent water, he glides at last into a long, narrow lake.

When he nears a wooded island, Queenie races up and down the boat, stepping over poles, dip net, and canes. Fifty

yards ahead, Junnie shuts off the motor, and with the boat drifting toward a designated spot, he rises, strides rapidly forward, and grabs a rope weighted with a hooked bar known as a grab hook. He drops this into the water and below it unerringly snags the net's stretched-out tail line. Lifting, lifting, Junnie finally reaches for the front end of his hoop net, which grudgingly breaks water.

Only moments before, this windsock-shaped contraption lay spread out across twelve feet of river bottom. Its seven hoops, largest at the rear, form a skeleton for the mesh. At the first hoop opens the mouth, and two hoops later looms the first mesh throat. An equal distance ahead awaits the second throat, tapered also and easy to slip through but nearly impossible to retreat from. A final chamber, referred to as the pot, holds the fish. Here also hang one or two bait bags, which typically hold soy meal cakes or cheese (skimmed off ends of barrel cheese purchased from factories) or a fish. How is a buffalo or flathead lured into this confinement? The net's mouth faces downstream, and particles of bait flaking off float in that direction. Fish pooling below follow them to their source upstream, where the hoop net mouth greets them.

Like a giant Slinky, hoop over hoop, the mesh is pulled through the air. As the last chamber surfaces, its contents thrash water. Junnie grabs a hoop, leans backward, and, straining slightly, flops all on the front deck. Mesh, hoops, mouth, and throats, some twelve feet worth, pancake into an eight-inch-tall pile, topped by the pot. Junnie unties its knot and removes species. Out come two carp, tossed back into the river (at six cents a pound, not worth handling), three

buffalo, dropped into the hold below, and a lone flathead, which thumps against the sides of a bright blue tub, Queenie yelping in accompaniment. "Got a hundred pounds out of it two days ago," says Junnie, "but they shut down the dam. Now they ain't much current; bait stays in the net. You need motion to send it downstream. Advertise your product. Helps keep the mouth [of the net] open, too."

Whack! Whack! Junnie holds up the net while caning it fifteen times to dislodge any silt, sticks, or leaves that have adhered to the mesh during submersion. "Davey cleans his off with a hose," he explains of the less taxing method, "but the motor [that drives it] makes such a racket it scares off the fish an extra day."

Finally, from a bait bag hanging above the last chamber, he removes the last few crumbling bits of soy meal. Replacing them with two pounds of hard, crusty pieces that will disintegrate and float downstream over the next day, he submerges his net again.

Off he goes toward the next set, some hundred yards downstream, hugging close to the island's shaded waters. This excites Queenie even more, who paces persistently from one end of the boat to the other. She barks, perhaps catching scent of some coon or possum that recently tight-walked the springy boughs that hang above her master. She barks again, then looks back, mystified by Junnie's lack of interest.

A tree fallen into the water pushes him offshore ten yards where Junnie cuts the motor, again stepping the boat's length before snagging a net, unmarked, that sits below the waves. "Can't leave buoys anymore; people steal your fish," says Junnie. "It's gotten so bad the last fifteen years. Oooh yeah, pohliner don't want to sit out in that hot boat all day, come home with nothin'. Trap lines, too. I used to take fifty, sixty coons every year along a certain riverbank, just off the road,

but now these young kids come along and pick you clean."

Time after time, as Junnie approaches the unseen nets, whether nestled in a cove or set out near the channel, he unerringly snags them, if not on the first swoop then the next. Junnie explains, "I sight 'em up along a landmark, like this one with the end of the island. But that ain't enough; gotta have a backup further off: eagle's nest, beaver dam, tugboat buoy. Might be half a mile away, but two always. Poppy taught me that. But one standing, the other lyin' flat. Make a cross."

As he goes from net to net, Junnie accomplishes his tasks with utmost efficiency. Walking across the lower deck's narrow plank, then taking the eighteen-inch step to the upper deck, avoiding canes, nets, and buckets in spite of the boat's rolling motion, he strides unconcernedly, as if pacing a sidewalk. His every movement while fishing seems to be the result of countless time and motion studies, for where the flourish of one movement concludes, a second one begins.

Even taking of refreshment blends into the routine, disrupting nothing. With a cigarette dangling between his lips, he not only nudges the tiller with a knee or elbow but also patches a dip net that's come unstitched. Coffee is gulped hastily while he pilots the boat and scans the coastline for a trotline bobber or, like today, hoop net indicators.

Junnie says he prefers working alone, complaining, "The other man's always in a hurry to get back home. I like to sit in the boat and let her drift, or anchor up and watch an otter and her babies slide down the bank. Oh, they're full of mischief, them!"

As he moves onto a much larger body of water, the sun has risen high above the trees, gleaming off the wavelets that chuckle against the side of Junnie's boat. On the far bank, four hundred yards distant, a score of trailer homes are camped upon a field, while an island forms the closer shore. Though its trees and shrubs are denuded of vegetation, they stand upon a lush green carpet of grasses. The pastoral scene contrasts with the sort of fishing Junnie next encounters.

For no sooner does he hoist the mouth of a net than the water boils in wild confusion. And instead of jerking the load aboard as he did in the quieter sea, he now leans his entire body against the bloated mesh and straining metal hoops before landing its protesting load upon the deck. Furiously the catch writhes and twists, spraying the air with thousands of slimy droplets. There, snaking among the few chubby buffalo and carp, are a dozen muscled and sinister looking fish: northern pike. Although each would be a joy to a sportsman, they are a nuisance to Junnie, who must untangle them from the mesh and grab hold of their gills while avoiding the chomp of their ferocious teeth and clamping jaws that close with a frightful sound before returning them to the river. "That's why the pohliners ain't catchin' no blue gills or crappies; northerns is eatin' 'em. I told the game warden they oughta make 'em commercial fo' while. Otherwise, they ain't gonna be no other fish on the river."

Net number seven is crowded with so many of these predators that as Junnie tugs against it, he slips and tumbles across the deck. Quickly regaining his footing, he finally flops the load aboard and, while wrestling the northerns free, reveals one of his trade secrets. "When I put down a new coat of paint, I sprinkle sand atop it. Dries right in there and gives you a real good footing, although this year I pretty much

scraped it off. I'll repaint it next week. Son of a bitch!" he says, working the shoulder on which he just landed.

"Goddamn!" yelps Junnie again as a pickerel mouth snaps shut an inch from his hand. "They'll take off a finger. Come after you, too. Oooh yeah, last week one leapt two feet off the boat and bit into my hand, right through the glove, blood squirtin' all over the place."

Ill luck dogged Junnie on this body of water during the flood of 1993 as well, when the current raged above its normal pace. "Whole trees come raftin' through, roots grab hold of a net, yank it loose, drag it on down to Gulf of Mexico. Hauled off nine sets, but not as bad as [Ron] Dickau [from Thomson, Illinois, who fishes these waters]. He lost 'bout four times that many; thirty-four he said."

After dropping off his fish at the Fulton market, Junnie begins a fifty-mile drive back to Bellevue. Halfway home he stops at the edge of island town Sabula, Iowa, population 824, for a beer. Inside, *Jeopardy* plays low on the television while the bartender restocks pretzels and potato chips above the bar.

Junnie sits some fifteen minutes, chatting idly until he abruptly recalls an earlier topic, one begun about net landmarks on the river well before the fog had burned off the estuaries. "There's more to it than that," he begins. "When you and I are sittin' here bullshittin' about the Cubs, the World Series, someone thinks I'm occupied with baseball. Uh-uh. My mind's on the river. I go from set to set, the four in Catfish Slough, the six along the island, four more stuck back in Kennedy [Slough]. Rememberin' each landmark, each backup, too. About a dozen times a day, while rakin' leaves or patchin' nets or could be chowin' on some scrambled eggs. Then ten o'clock I'll go to bed, my head'll touch the pillow, but never shut my eyes until I see the sets. Over and over. Oooh yeah! Ain't never lost one yet."

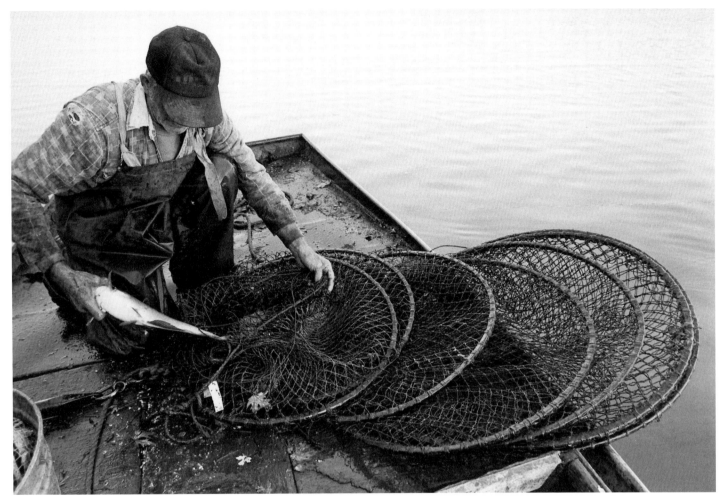

Junnie Putman removing a fish from his hoop net

No, I don't know no commercial fisherman that's retired rich, but there's lots of things in this world more important than money.

—THELMA PUTMAN

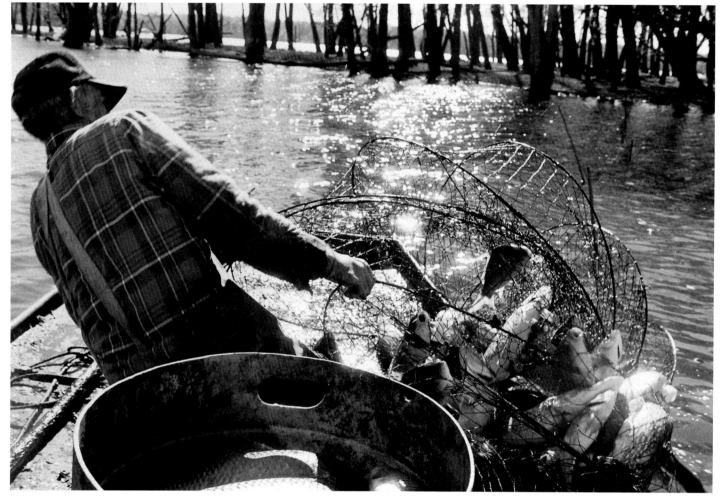

Junnie raising a hoop net filled with buffalo and northern pike

I fished with my brother, Willie, for three years there. He's a good worker, but you can't make it with another fisherman. Sure, things is smoother, like handlin' boats and nets, and the time goes quicker. But expenses got so high and prices dropped so low, we had to go our separate ways. Blood's thicker than water, they say, but I got a wife and daughter to support.

—WAYNE KRESS

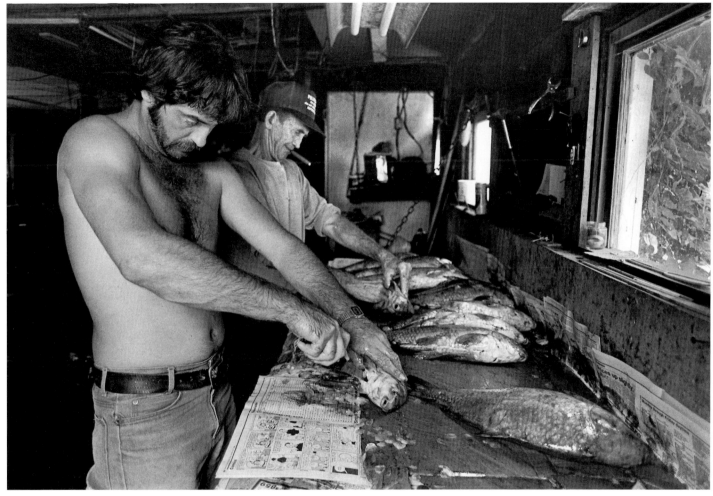

Little Dave Putman *(foreground)* and Big Dave dressing buffalo and carp in Big Dave's shed in Bellevue

Summer after eighth grade, I fished with the old man. Come September he says, "You're only fourteen, but you're as good as a man." I says, "If I'm as good as a man, then there's no need of my going back to school." Been on the river ever since. Fifty-five years. I remember him sayin' that as if it was yesterday.

—BIG DAVE PUTMAN

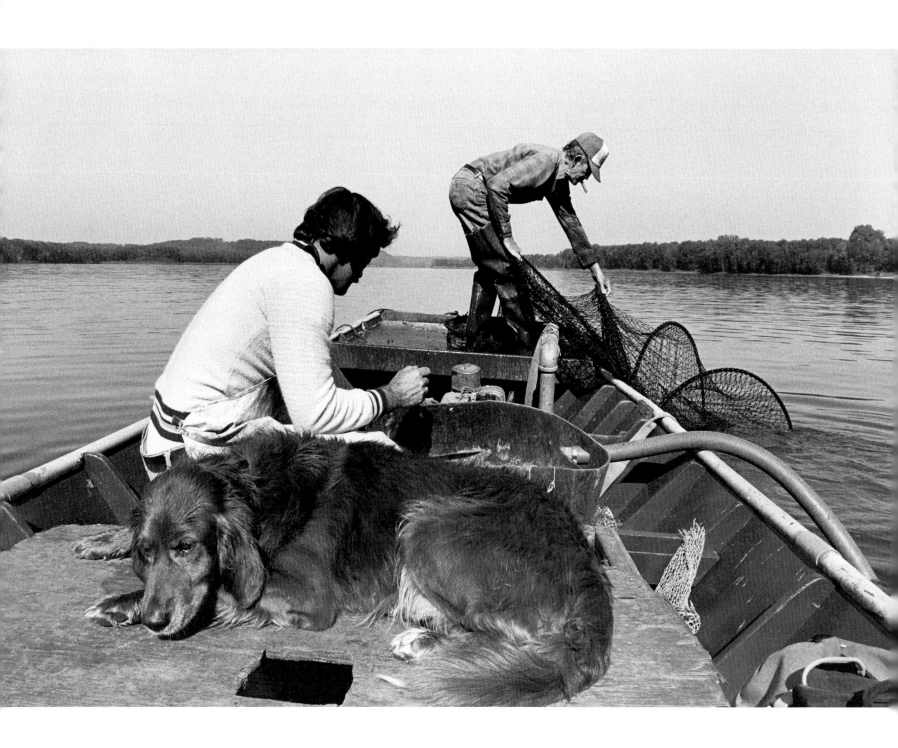

When we go to bed, I'll start talkin', but about five minutes after her head touches the pillow, Thelma falls asleep. Not me. I'll toss and turn for a couple hours. Countin' nets, I am. "Let's see, I set two here, another three there . . ." It's pretty easy to forget 'em.
—BIG DAVE PUTMAN

Little Dave Putman *(left)* sorting fish while his father resets a hoop net by flats—
patches of shallow water well out in the river—south of Bellevue

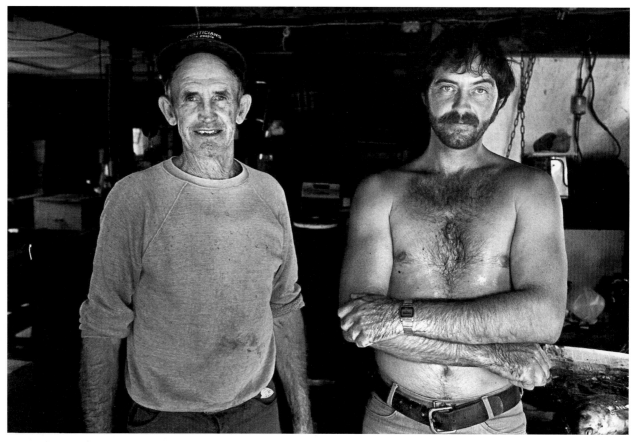

Big Dave Putman *(left)* and Little Dave after cleaning the morning's catch in Big Dave's shed

Yankin' and liftin' their whole lives, that's all they done.
—LITTLE DAVE PUTMAN

She's part hound, which makes her bullheaded, and the setter makes her sassy. Won't do nothin' I tell her 'less she wants to. But she loves that river. Won't let me go without her. And she hates to leave. If I stop at the market on the way home, she'll follow me out. But once we get back to the shed, she stays in that cab. Overnight even. 'Fraid I won't bring her 'long next time. I tried to take her out a couple of times, and she bit me.

—BIG DAVE PUTMAN

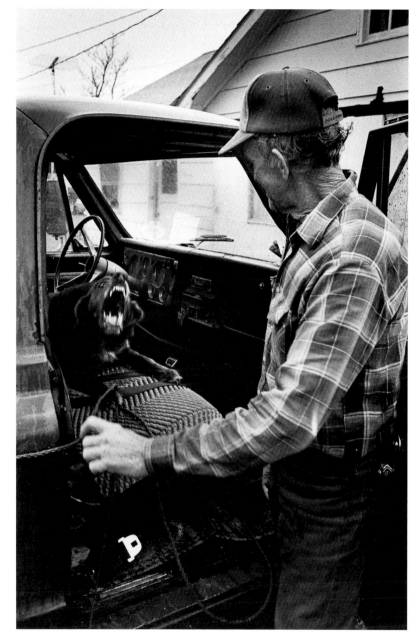

Big Dave Putman attempting to remove his dog from his truck after a day on the river

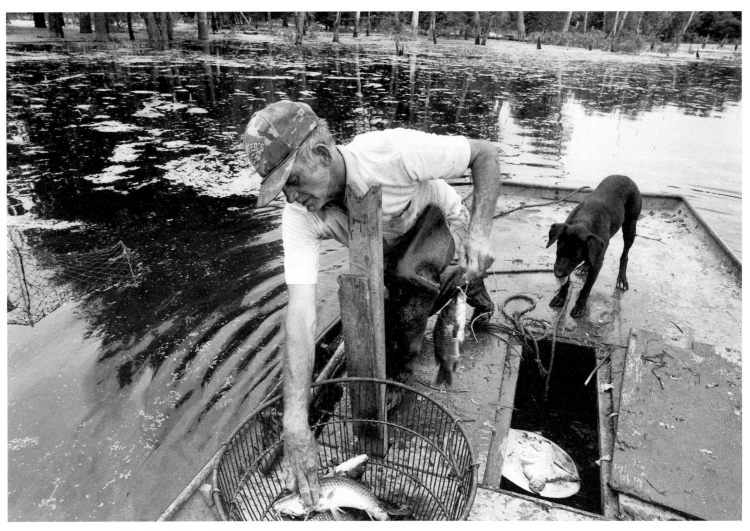

Junnie Putman grabs fish with which to bait hoop nets to catch turtles.

6 Hoop Nets and Turtles

Use of the unwieldy 150-yard-long seine requires a crew of seven, affording Junnie some company. During the rest of the year—from around the middle of March to the end of October—he fishes alone. Years ago, before expenses rose and fish prices plummeted, Junnie and a coworker would run trotlines and raise hoop nets. In some cases, the men shared the heavier work while one of their wives would perform lighter work, also breaking up the day's monotony. Today, no more solitary enterprise exists on the river than trapping turtles.

To reach Junnie's first turtle net, staked in the mire of some dismal slough, requires a considerable journey and the traversal of a variety of waterscapes. Skimming four miles over open water, he enters an inlet that empties in turn into a lake choked with weeds and logs. A dense growth of trees that ring this pool, festooned with ivy and moss, adds further to the gloom.

Undaunted, Junnie plunges into the soup, but after little progress the motor sputters, chewing vegetation in low water. Junnie yanks it from the water, dropping its smaller twin beside it. Twenty yards ahead, it chokes, too, and must be lifted out by degrees until, barely spooning with its rotors, he progresses among the lily pads. A slim opening allows him to plunge the larger outboard in again, but only momentarily.

And so it goes: after much roaring, backing up, and charging ahead once more, he breaks free and finds himself floating upon a little stream, jet black and all but motionless.

Far off this brackish alley, perhaps thirty feet across, Junnie has scattered fourteen hoop nets. However, to reach them and the unstirred pools that snappers favor will take a good deal more searching than what it does to catch catfish. Putt-putting up the murky ribbon awhile, he spots a branch collapsed into the forked crotch of its neighbor. Thus alerted, he right-angles the boat and enters what appears to be an absolutely hopeless and uncharted region. Yet, among these boundless waters, interrupted by enough trees to all but canopy out the sun and occasional stands of bush, Junnie will navigate.

Another broken limb directs him forward, and eighty yards beyond he skims beside an oak, much of whose bark was stripped by lightning. Peering keenly ahead now, he slithers between a mound of earth (his fourth guidepost) and a dead oak, commenting, "Water come up another half a foot, I wouldn't 'a seen it." Finally, whizzing around a clump of growth, he sees sitting up in a brackish arcade his first hoop net, its top third arched out of water. Almost identical to catfish and buffalo hoop nets, it stretches an additional wall of mesh before its mouth, a necessary adjunct to lead turtles to the bait in these motionless pools.

Poling through the soup, Junnie notes only a bite remaining of the two-pound bait carp dangling from the net's exposed roof. "Good sign," says Junnie. But rolling mesh aboard, he finds the contents empty. "Son of a bitch!" Now he rotates the hoops slowly, inspecting their mesh. "Big boy chewed through it," he says, pointing to a gaping hole the snapping turtle left before taking out a large plastic needle with which to patch the damage.

Set number two is luckier. Wrestling mesh aboard, Junnie finds a dozen turtles of various sizes. They clank upon the deck like crusted doubloons just salvaged off an ocean floor, remaining still. Queenie, puzzled, sniffs at them, then yelps maniacally when one grows legs and crawls to water. "Queenie, cut that out, girl!" barks Junnie as he nudges larger terrapins and snappers into the hold and slooshes runts into the drink, Queenie yapping still. Finally, with net re-baited, he slides the works back into the swamp, stretching it and its lead line as long and wide as possible, then thrusts the stake into the bottom.

Prodding for turtles requires an even greater effort. Before inland streams freeze up, the prodder walks along a bank looking for accumulations of sticks and logs. Sighting one, he plunges down the twelve-foot high embankment and pokes with an aluminum point in the mud. When it produces a hollow sound, he turns the rod over and, before the napping terrapin or snapper can scurry off, works a hook under its shell. Then a scramble up the bank lifts him and his catch above the flow once more. Two hundred yards farther on, perhaps after slithering under a couple of barbed wire fences, he might come upon another likely residence.

On and on it goes. Late in the day, however, the turtler must wade, climb, and scramble with two hundred pounds of a shifty load upon his back. Under the strain, cartilage tears, backs pull, or ankles pop. Junnie leaves these labors to those under forty.

Going toward another set, Junnie loses his way. He skitters over the surface, peering left, right, and straight ahead, all to no avail. He then retreats two landmarks before racing forward, reaching an area similar to the one just deserted. Describing ever-widening circles from a designated point, he comes across the wayward mesh at last, proclaiming, "Nope, I never lost one yet."

This net, too, is chock-full of hard- and soft-shelled clawing animals, and Junnie strains mightily to hoist the haul onboard. But as hard a tug as this is, his most arduous labor occurs when resetting the net. For some reason, it collapses over and over, refusing to stretch out properly. Time after time Junnie drops to the water and wades the mucky bottom to make an adjustment before clambering aboard his high-bowed craft, achieving this only by scissor-kicking with his waders. Then, net cord in hand, he motors cautiously forward—and still the net resists once more.

Exasperated, he takes in several deep draughts of air. All morning he has worked in silence, no warbler having volunteered its notes, no blue jay bugling through the watery glade. Even the *ack-ack* of the kingfisher, common where the Mississippi hurries undelayed, fails to penetrate these stagnant reaches. Now, as Junnie stands, perspiration weeping from his pores, a lone cicada begins to nag from an upper branch. Over and over it drones, trying to break into an upper register, rising, falling, rising, mocking the futility of his efforts. Swatting a mosquito from his cheek, Junnie leaps into the marsh once more.

At last the net is set. Yet even in this near one-hundred-degree heat and heart-stopping humidity, only when ensconced at the tiller, cigarette dangling from his gnarly, callused fingers, will Junnie partake of any liquid, and then only a sip or two of coffee, which still pours scalding from its thermos. ("No, I've never seen a Putman take a sip of water," says Junnie's nephew Little Dave.)

By three o'clock, his fourteenth net is raised, plundered, and re-baited. Gliding quietly, he announces to his dog, "We're goin' home now, girl!" Over the moody waterscape he slides, disturbing only an occasional sunning reptile, who slips into the drink at his approach, or a panicked muskrat, veering through the muck. The sun reemerges at last, forming glinty, random patches where foliage allows, but otherwise it's dark. Indeed, one would associate these exotic and overgrown locales with Florida, the Okefenokee, not the otherwise undecorated terrains of Iowa or Illinois. "Cold one sure taste good 'bout now," croons Junnie over the humming of his motor.

Either the cough of Junnie's truck motor or the sound of fish thumping against his tubs wakens Bellevue's sleepy south end and draws an assemblage of onlookers. By the time he hoists open the garage door to his market and drives in, brothers Richie or Dave, friend and neighbor Rodney Ehrler, or any number of old-timers may stop by to gawk and chat. This particular day, however, only Mary, who is not scheduled to work at Hawk Hollow Antiques, leaves off cooking to see what the Mississippi has yielded to her husband. After admiring several large snappers, she reminisces. "Oh, for ten years after we was married, I worked with Junnie. No, I wasn't liftin' nets or raisin' lines, none of the heavy work, but I'd seine mud holes and cricks out with the minnow net for crawdads and fingerlings. Then I'd drive [the] truck when he held the net for grasshoppers [and] take fish to the market with him 'cause he didn't get his driver's license 'til he was twenty-five on account of failing the reading part.

"And of course I baited his trotline hooks, maybe fifteen hundred or more a day. Crayfish, mayflies, grasshoppers, carp minnows, jelly beans, even Ivory soap. One whole summer we used that; cut it up in little squares. Oh, the catfish took it like crazy. I put anything on there. Except catalpa worms and leeches. Them I wouldn't have nothin' to do with. They was too slimy.

"Around 1970, me 'n Junnie built the market. We put in a cooler, couple live tanks, and a refrigerated counter. We done good, too. People come from all over. And if business slowed, why we'd drive around to the farms, sell door to door.

"But it turned into a twenty-four-hour operation. You couldn't sit down to dinner without someone ringin' for dressed catfish or smoked carp. Might be a three-dollar order, but you still had to excuse yourself and go out there.

"All those hours standin' on that cold cement floor. After a while your legs just couldn't take it no more. That's where my circulation problems come from, I believe."

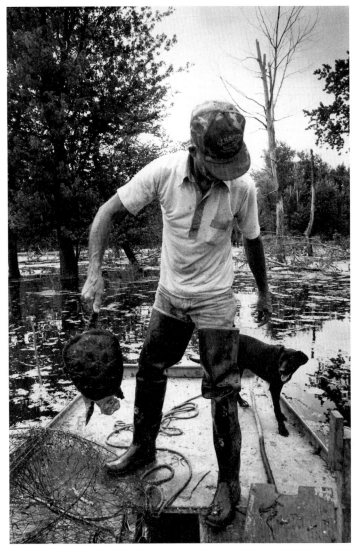

Junnie Putman preparing to drop a snapping turtle in the boat hold

The old man took me proddin' when I was nine. He was a farmer; only went a few times a year. I got hooked pretty quick, though. Every day I put on his waders and stumbled down to the nearest crick. Boots blistered my feet, could barely see over the apron top, but I was bound and determined to get turtle.

—AL LIEBFRIED *(describing "prodding" with a nine-foot aluminum pole)*

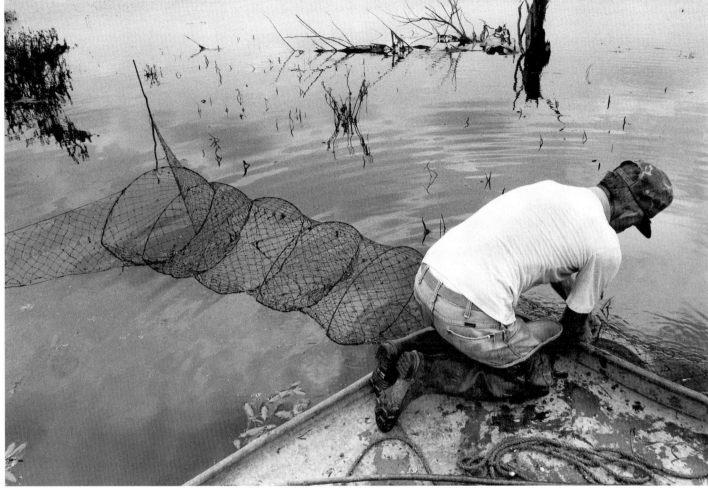

Junnie re-baiting a hoop net in the waters off the Mississippi, lead net mesh visible at far left

On days like this them rotten trees come down. You don't expect it 'cause the river's smooth as glass and no leaf's shiverin', but that's when a half a ton of log breaks off, a whole oak maybe snaps, comes down across your bow. But when it's howlin' down the alleys, water's sloppin' above the boat, she's kickin' in the bayous and backwaters . . . nothin' falls. Only when it's hushed; those days I keep my anchor in the boat, except out in the current, they topple then. Or nudge one with your oar and down she comes. Oooh yeah! It's easy done.

—JUNNIE PUTMAN

Big Dave Putman *(left)* and Junnie in front of Dave's shed discussing river conditions after a day of fishing

Him and his dad was never close to begin with. Seemed like no matter how hard Junnie tried, there wasn't nothing he could do to please him. One time when we found out John was selling off some property, Junnie offered him ten thousand dollars for a half a lot, which was way above the market value, to break the ice between 'em as much as anything . . . and then he sold the whole to Davey for about the same's my husband offered him for half. Now Junnie never mentioned it or nothin'. That's the way he is. Although I know it bothered him a good while. Without him sayin' nothin', I knew. And nobody in the family could figure it out neither.

—MARY PUTMAN

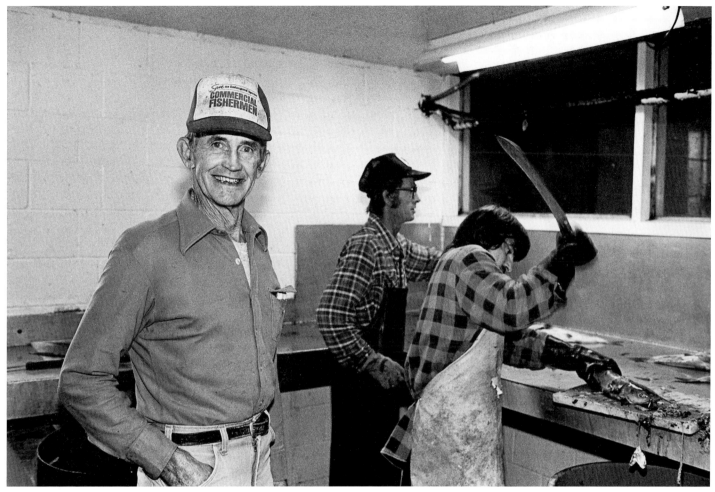

Big Dave Putman after selling his catch at Schafer's Market in Fulton, Illinois, and a worker cutting steak-sized pieces from catfish in the background

Grandpa always told me, says, "Anytime you go into a joint, always eye up something you can get your hands on. A pool cue or a hammer . . . never know when you might run into trouble."
—BIG DAVE PUTMAN

At the Putman block party, Big Dave Putman stands at far left next to neighbor Barb Mickel.
Seated from left are Dave's grandson Ryan and Dave's wife, Thelma.

7 Social Life and Recreation

Big Dave describes the 1930s, when his parents scrambled to feed eleven children and couldn't provide for their amusements. "Remember how we made our skis back then? From an old barrel we built 'em. Work off the metal hoop, then take a couple staves. The widest run the best. For straps you cut some rubber strips off of old tires and lash 'em 'cross your feet. Now work your tallow 'long the underside until it's slick. And then look out! Scoot down them hills just like you was in the Olympics, boy!" Indeed, commercial fishing requires up to sixteen hours a day. Thus, in the late 1950s and early 1960s, Junnie, in order to spend time with his children, would bring them to work. Midwinter, for example, while he penned buffalo and perch below the ice, Peggy and Tami tagged along. When not watching Papa, they would lace on skates and describe circles around his operation or race from shore to island and back again.

Many a commercial fisherman, Junnie and Dave included, when working open waters would wrap his two- or three-year-old son in a blanket and place "the little shit in a fish box" from which he could watch Father lift lines and raise nets. Maybe a year later, he would take him trapping; Junior would sit atop a pile of beaver and muskrat while Father pulled the sled along frozen bottoms and riverbanks.

A few years later, as Mary recalls, "When the kids could care for themselves, me and Junnie camped out on an island. He set out a few trotlines (instead of the usual thirty), and I'd leave out a pole or two. We stayed out there five weeks one time. I only come in to town for flour and water. Oh, the kids might come out for a couple days, but otherwise we was alone together. I'd pollywog [sit in shallow water and grope] for clams, for bait. Livin' outdoors like that, I got so dark everyone thought I was an Indian. Oh, I was brown as a chestnut."

Knowledge of fish habits gleaned from keen observation and countless hours spent on the river gives the Putmans an edge over recreational fishermen. Striped bass, the Putmans know, ride herd for hours on a school of fingerlings, nipping at strays. Then, at feeding time, they tighten the circle, panicking their prey into a cove of shallow water where they are easy to harvest.

Putmans will cast into the midst of this five-minute frenzy, hooking a fish each time. They also know that instead of trying to get hold of the wriggling fish once it is landed, avoid its prickly spine, and then work the hook from its cartilage, they can merely slap hook, lure, and fish against the side of the boat, often instantly freeing their lines if their quarry is slightly gaffed. Ready to recast in an instant, Junnie can "get our limit fo' they gut time to run out agin."

The Putmans are avid hunters and anticipate each season eagerly, be it deer, goose, duck, or turkey. In between times, they enjoy recalling past successes, such as this long-ago tale full of trickery related by Richie Putman.

"Mallard's last duck to hit the flyway, leave in wintertime. They paddle around in the middle of them deep pools where no one can get a shot at 'em. Keep the water open. While ago we'd find a shallow pond already frozen over and pour a bucket of blue dye on it. Then we set out our decoys, sit behind the reeds, and wait.

"Didn't take long before a flock come by. Circle around a couple times, drop down and taxi in. Oooh, you oughta see 'em scoot. *Ooop!* the wings shoot up; they skid a couple hundred feet. Oh, shit, they come in at a pretty good rate of speed; there wasn't nothin' to stop 'em. Oh, it sure was comical to watch 'em slidin' on their asses, plowin' into our decoys, scatterin' 'em. First time, Davey laughed so hard he could hardly raise his gun. Although we got our limit, *boom! boom!*, and then some.

"But it wasn't hurtin' nothin'. Back then they numbered in the tens of millions, thicker than mosquitoes they was. Before the government put in the dams and levees, farmers drained the swamps and potholes, took away their habitats. Besides, Depression hadn't left. A lotta hungry mouths to feed in Bellevue yet."

The Putmans relish current stories as well. On the last day of deer season, excitement pulses in Junnie's cinder-block shed when one after another of the crew returns from the field. First is neighbor Gus Glasser and son D. J., who hang their animals over a pipe on the ceiling. Gus must tell about one that got away, however. "This great big doe come within twenty yards; I had a clear shot and everything. But before I could get my gun up she disappeared . . . just like that. I mean there wasn't much timber in there. Then all of a sudden I see her breakin' away about two hundred yards off. She must have spotted me and got behind that tree trunk and just backed up, keepin' the trunk between me 'n her until she got out of range, then off she goes. Now don't tell me those are dumb animals."

An hour later, Rodney Ehrler and Junnie unload their kills and drop them onto newspapers. "That's a nice one," Gus says of Junnie's large doe.

"He hit her four times out of five," says Rodney.

"She was really flyin'," says Junnie. "Goin' through the bush, I shot her hind leg. *Wham!* She keeps on movin'. *Wham!* I cut off her front leg at the knee. She don't break stride. I get off another; missed her clean. Pumped another in her guts. That doesn't stop her. She's scootin' over them dead leaves, then *wham!* I shot her in the back and she drops."

All that evening, talk centers on the hunt. In turn, each man jumps from his chair and, with arms in front of him, sights down an imaginary rifle barrel as he recounts each shot. Bullets whistle clean through the air again; others whang into trees, some of these carrying fur with them. Once, in between narratives, Gus wonders aloud how the deer jumps about the uneven terrain without injuring itself, especially over the rock beds broken by so many crevices. "Be easy to step in one and crack a leg. They never do it, though. Have you ever seen one, June? Rodney? No, me either."

Someone fusses about the hunt's results. Junnie, who drove deer with Rodney that morning, says, "We let too many get through. Can't rush them animals. Just go a little bit, then stop for 'bout two minutes. Don't make no noise and keep your eyes open. Give 'em something to think about, but don't

scare 'em too bad. Stop, and then walk slow over your next piece of ground. *Slow,* Rodney."

At evening's end, Junnie and Richie argue about the feasibility of fishing the next day, Richie doubting whether there will be open water. "You ain't goin' anyway. S'posed to be ten above tonight. She'll freeze up harder 'n a pecker," he says.

"Won't be no ice if the wind keeps howlin'; water's movin' too much, Richie," replies Junnie.

"Oh, she'll ice up all right," says Richie.

"Richie, you're just gonna drink coffee all day if you stay home."

"Hell, I ain't goin' 'cause you ain't goin'. Just listen to the weather reports."

More often than hunting, commercial fishing dominates these conversations. Occasionally, a recent incident recalls an older one, such as the narrow scrape Junnie's father experienced during the last days of Prohibition. "Poppy was a commercial fisherman," begins Junnie, "but he run bootleg, too. Buy from some of these moonshiners around Galena and sell it to people in Iowa. He'd put all his bottles in the bottom of the boat and cover 'em with fish. Anybody'd see a load of buffalo and wouldn't think nothin' of it. One Sattidee [Saturday] night, he come rowin' across with a full load and singin' a happy song. He'd been samplin' the product, see. Oh, he was singin' loud. But when he come to tie in at the dock, they beamed all these searchlights on him. 'Who's there?' says Poppy.

"'Federal agents.'

"'What do you want with me? I'm a commercial fisherman.'

"'Show us what you got in the boat.'

"'Just a load of fish, but go ahead and search it. I'm goin' to dinner. Be back in an hour.'

"He climbed over the bank and went to the L and J [a local restaurant]. When he come back later, everything lay just like it was; nothin' been disturbed. Next mornin' he went and got rid of the whole load at a revival meetin' over at Maquoketa."

"He done the right thing," says Junnie's son-in-law Ron Purvis, "tellin' them to go ahead and look. Didn't make 'em suspicious."

"And back then all the agents wore a suit and tie, see. None of 'em wanted to get their clothes dirty," adds Junnie.

The following Saturday at lunch, one old story begets another. "One time Uncle George's finger got infected," begins Mary. "It was pretty bad, but he didn't want to see the doctor. One of his workers said to lay it on the table and he'd cut it off. Old George had a different handshake after that."

"It was a lot rougher back in them days," says Junnie. "One day the game warden stopped Jack Smink to look in his boat. Grabbed the bow, but he didn't get a good grip and she kind of slipped away from him. Old Jack picked up his ax, said, 'You put your hand there again, I'll cut it off.' Game warden reach out again. Didn't think he'd do it, see. Well, Jack swung on 'im. Sunk the blade two inches into the side of the boat, halfway up to the handle. [If the] game warden left his hand on there, he'd a cut it clean off."

Dave concludes, "All them Smink brothers was like that. Wouldn't let someone's chicken cross their yard. Come out with a club, they would. They lived right next door to us. None of 'em married, either, any of the five. Stayed bachelors all their lives."

For the most part in my early years with the Putmans, before our friendship bonded, I preferred a role as observer, listening to their words, photographing their actions and expressions. Occasionally, however, I was drawn unwillingly into events, as I was in the following story.

After a frustrating day on the river, the crew of six, along with a nephew, Billy Reistroffer, who works at the lock and dam, meet in the market. Some lean up against Junnie's boat, which half fills the room. Two more stand near the wood-burning stove, and others form a semicircle seated on steel folding chairs. I am accorded a seat between Junnie and Billy, who is a lean six foot two inches. He walks and speaks rapidly, eyeing listeners keenly. His prowess as a woodsman and hunter go back to high school when he was given the nickname "Timber Wolf."

"Rich, I grew up around here, know all these guys. Good honest, hardworking folk, Rich!" he says, pounding my back vigorously with each recitation of my name. "But you wanna know something? Before Vietnam I never killed anything. Never even shot a rabbit, Rich! No, sir. Ask any of these fellas. But that Southeast Asia deal, that had to be a son of a bitch!

Oh, they trained you, all right. Take you up in that chopper, settle her over the target . . . and *whammo!*

"Then on the ground there's your hand-to-hand combat, pistols, bayonet, grenades. That shit'll change you, boy. I used to trust everybody; but today, someone comes at me, I'll squeeze one off. Don't think I won't," continues Billy, who admits the next day that most of this was "whiskey talk."

"But don't worry about these boys here, Rich. You're safe with them. Me, too. But like I say, Rich, any outside force advances on us and the situation don't look right, out of the holster she comes and right between the eyes. Combat ready, Rich!"

Just as I shake off the effects of Billy's last slap, Doug Griebel walks over, Junnie's whiskey bottle in hand. "Rich, if you can't kill this, you're not a man," he says, holding it up. I take it from him and sip politely, after which he puts the bottle to his lips, tilts back his head, and drains the remaining three inches before depositing the empty on Junnie's lap.

A second later, the room explodes in sound and shattering glass as Junnie slams the offending empty onto the floor. Dead silence falls upon the room. I sense the pumping of my heart. "I told you to save me a hooker!" Junnie bellows. Rising, he states, "I ain't gonna fuhgit this, Doug. I ain't gon' fuhgit it." As Doug moves off into a corner, everyone resumes talking, although Junnie's mood sours by the minute. Alternately, he glowers at a crew member or mutters, "Ruined the party, Doug," and, "Spoiled a good evening."

After some time, I feel a tap on my shoulder. It is Junnie. "Rich," he says to me, his piercing eyes looking deeply into mine, "Rich, I want this to go in your book: Rich, I hung my

uncle. I hung my own fucking uncle!" Everyone in the room continues talking, some boisterously, but their words fuse into a murmur. And though my host speaks low, gutturally, indistinct at times, I comprehend his every syllable.

"Back then we was gettin' six cents a pound for dressed buffalo, not thirty-five like today," he began, "but it was still pretty good. Well, 'bout fo' 'clock Uncle George calls, says if we bring him fo' thousand pound next morning he'll give us nine cents. But they had to be there at six. One minute after and there ain't no deal.

"So me 'n my partner start loadin' up. Just as we're pullin' out, the phone rings. It's Jocko again—that's what everybody called him. The fish gotta be dressed, too. That was okay 'cause we knew a couple sloughs where there was plenty fish.

"We get home by 'leven and start cleanin'. Then 'bout three, Jocko calls. Says they gotta be boxed, too. So we speed up, dress all the fish, make boxes, ice 'em, and get everything to him by six o'clock sharp.

"Then we leave, have breakfast, take a little nap and shower. Around ten we go back and ol' Jocko's still there, jokin' with some of the fellas that work for him. Doesn't have time to notice us, though. Then we see this big envelope stickin' out his back pocket. Says Kansas City on it. That's kinda funny, we thought. So we brush by him, lift it, and go outside. Well, whaddya know; it's a government order for fo' thousand pounds of fish, dressed, iced, and boxed. And you know what they was payin? Forty-one cents. He give us nine, and we had to make boxes, too. So we go back in and I ask him, 'Hey, Jocko, who's your friend in Kansas City?'

"'I don't know nobody in Kansas City,' he says.

"'That's funny,' I says, ''cause these people addressed this to you.'

"'Where did you get that?' he says.

"'It was layin' on the floor,' I says.

"'Give it to me,' he says, 'you stole that out of my pocket!'

"'You can have it,' I says, 'but you owe us another six cents a pound. That'll make it fifteen.'

"'You crazy bastards; you got your nine cents.' Then he picks up an ax and heaves it full force. Went right by my head and stuck in the wall.

"'That's it,' I says to my partner. 'Grab the son of a bitch.' He lit out the door, but we got hold of him. Oh, he let out a yell! So we put tape over his mouth, tied his hands and feet. Then we tossed him in the truck and drove outside of town.

"'All right,' I says, 'get me sixty feet of lead line.'

"'What for?' my partner says.

"I says, 'We're gonna hang this cocksucker with the same cord he screwed us with.' Then I throw it over the lamp-post and tie it 'round his neck. When I pick him up, he squirmed like a little pig. He wasn't a very big man, see. 'Okay,' I says, 'when I count three you kick away the fish box. One . . . two . . . three!'

"Ol' Jocko drops off, but nothin' happens; he just dangles, kickin' and kickin'. Didn't snap his neck or cut off his wind. Just swingin' back and forth, back and forth. But after a while, he starts turnin' blue. Then we hear that mean little cough of his, 'Hack, hack.' Tough old bird, he was. Just when we think it's the last of him, the lamppost starts to bend. It crooks and crooks until at last his feet touch the ground.

"And you know, Rich, after that he never gave nobody no trouble. Nice as a little boy. If you go down to Point Pleasant

today, over by Cliff's [Ennis's] place, you'll see that lamppost is still bent. Nope, they ain't fixed it yet."

A moment later Junnie's wife, Mary, scolds him, "It's a good thing you didn't kill Uncle George. They would have put you in jail."

"Now, Mom, don't worry about a thing," says Junnie, "we already had his grave dug way back in the slough . . . they wouldn't have found him in a thousand years."

The women meet separately most evenings. Convening next door to Junnie and Mary's at Barb Mickel's are Barb, Mary, Thelma, Thelma's daughter-in-law Donna (Little Dave's wife), and Mike Specht, a retired farmer and friend of Barb's, a genial fellow who stubs out half a pack of cigarettes during an evening. To the static of the police scanner's chatter, the evening progresses. The tone is solemn, measured but spiced with an occasional salacious interlude. They lead off with the day's gossip: a granddaughter has enrolled in beauty school; a patron brawling in the Lock and Dam Number Twelve was arrested. Eventually, they may take turns grumbling about their husbands, emphasizing their overlong workday while listeners nod in assent. On the other hand, both Mary and Thelma have said of their spouses, almost in chorus, "No, I don't know no commercial fisherman's that's retired rich, but there's lots of things in this world more important than money."

Every second Saturday in August, the Putmans have their annual block party. That morning, Junnie, Richie, and Rodney collect picnic tables and chairs from their neighbors' yards, unload them from pickups, and set them across the four lawns north of Junnie and Mary's house. After muscling a heavy bench to the ground, Richie wipes his brow and says, "We had a baseball team called the Fishermen. Just played Sundays 'cause that was the only day we had off work. We beat the Bellevue Braves [a semi-pro team that played minor league teams in Clinton and Davenport]; pret' near run 'em off the field. Said we was too rough, come in to a base too hard. It was legal, though. Then they disputed a call and walked off the field after three innings. We was leadin' five to nothin'.

"Another time we played Andrew [a small town nearby]. But they didn't have no seats. We come back to Bellevue and drive over to the park. Took all the benches; uprooted a few and loaded 'em onto our trucks. Good thing nobody saw us. They woulda tossed everybody in jail. Oh, we was a pretty rough bunch back in them days, boy."

About 4:30 P.M., the extended family begins arriving in groups of two to ten, and by dusk their number swells to 120. As potluck dishes are placed on doilies, Rodney tells Junnie that he has just been laid off from his job on the hog farm. "That's okay," says Junnie; "catfish gettin' thick in the flats. You can work a few weeks for me, leas' 'til you get unemployment."

Because the Putman home faces Route 52, the highway through Bellevue, many neighbors honk and wave as they pass. Junnie motions for them to join the festivities. Ryan Putman, Larry's six-year-old, sits next to his grandpa, Big Dave. When the youngster goes for food, Dave says, "He and his younger brother go on the river with me. Used to put the little ones in a fish box. Now I let 'em do a little work, run the boat. Gotta watch 'em, though. They like to gun it wide open, and you can easy take a spill that way."

At 10:00 P.M., about twenty party-goers adjourn to the market where a place is cleared for the musicians. Soon the room swirls with motion. Dave and his cousin Eddie usually pair up with their wives, though Junnie mixes partners some. Escorting Mary to their table after two dances, he meets his daughter and son-in-law rising from their seats. Junnie pushes Ron back into his chair with one arm and spins onto the floor with Tami on his other one.

No one stands alone for long. Richie Putman might walk over and put his arm around a friend and squeeze his shoulders together as if he was an accordion. Doug Griebel whispers something mischievous to Little Dave, and Rodney remarks what a good party it is ("Nobody's got hurt yet"), a reference to parties of long ago. Junnie, on the way back to the dance floor, nods to a group of friends and comments, "Ain't they a bunch of river rats!"

Junnie's sister Grace Steines asks a neighbor to dance, and when he accepts she says, "I'll lead." She is seventy-two, tall, raw-boned, and a hearty dancer, her strong arms pumping out the music's beat. "I used to run a fish market right here in Bellevue," she says. "I bought from all the Putmans and most of the other fishermen around here, too. And I was the best at dressin' fish. Nobody was faster 'n me. Gut a thousand pounds in half an hour. *Wheesh, wheesh,*" she says, running an imaginary knife through buffalo gullets. "Go on, ask Junnie. He'll tell you."

Every October, Junior and Pauline Hall, relatives from Clinton, motor up the Mississippi to help with the annual harvest of the grapevines behind Grace's house. Two more of Junnie's sisters, Irene Steines (at one time married to Orville; Grace was married to Orville's brother, Walter) and Betty Budde, interrupt their picking to fuss over him; his jaw and chin are heavily bandaged from recent surgical scraping of cancerous skin.

Later, all adjourn to Betty's deck for cider and coffee. At this time of day, the sun still kneads warmth into one's bones. Overhead, a breeze rustles through the stiffening leaves. During this quiet and laborless hour, away from high water and barked commands, the family's closeness emerges. You notice it first in the way they alter one another's names: Grace becomes Gracie, Dave is Davey, Irene is Reenie, and John, the youngest male, tagged Junior, is known as Junnie.

Around 4:00 P.M., the air cools, and everyone shivers when a cloud obscures the sun. The Halls rise and amble to the dock. Over the next six weeks, the mashed fruit will ooze juices in their basement, by Thanksgiving achieving a sweet, winey taste and an excuse for their next visit north.

Work and leisure for the Putmans seam indistinguishably together, each pursued with equal vigor. For example, Junnie begins one thirty-two-hour period by raising twenty-seven trotlines and cleaning his catch ashore before handing the buffalo and flatheads over to Big Dave. After a quick shower and a haircut, he rides thirty miles to Maquoketa, Iowa, for his niece's wedding.

By 7:00 P.M. at a rented hall outside Andrew, Iowa, the real festivities begin. No sooner does the band start playing than Junnie and Mary are on the dance floor for three numbers. Enjoying a cold one on the sidelines, he then gets up for two more numbers with his daughter Tami. Halfway through

another beer, he nudges Mary, and the two reel through another couple of songs. And so it goes spinningly, as a regiment of dead soldiers—Old Milwaukee cans—forms ranks along their table, captained by the occasional shot glass.

Around 1:00 A.M., the party filters out. As Mary and Junnie stand before their Buick, I, the designated driver, hold out my hand for the keys. Junnie snatches them from Mary. "Don't you want me to drive?" I ask.

"Get in the car," says Junnie soberly, though wobbling like a newborn colt.

"Are you sure?" I query. I look into Junnie's eyes, and two unforgiving embers glow back. "You sure now?" I ask again in the most conciliatory tone I can offer.

"Don't argue with me, Rich," comes the reply. "Please don't argue with me."

We rumble over the parking lot, crunching stones before creeping onto the two-lane where we lurch into medium speed. For some distance we cruise at this pace, straight as an arrow, but then slow down or speed up as Junnie's attention waxes or wanes. Then in mid-road, the car comes to a stop and its front door swings open. Out steps Junnie. "Okay, Rich, you take over."

I drive a mile before the road splits right and left. "Which way do we go?" I ask.

"You figure t'out, Rich," comes the unsympathetic tenor from behind me. For nearly an hour we wander the countryside, uninformed. At one point, we miss a turn and spin off onto a gravel path. Before braking, we are swallowed by a canyon-like area. Rising all around are the limestone walls, glinting eerily in the headlights, of a quarry gouged out of a hillside. The only counsel from the back seat: "Anything happen to the car, Rich, you never make it back to Chicago."

At 2:30 A.M., we reach Bellevue. Walking to my door, I laugh off Junnie's slurred invitation to go hunting before sunrise. "You better be ready, buddy," Junnie reasserts.

Sure enough, I wake to Junnie's pounding two hours later. "Let's go goose huntin'. Me 'n Richie got the coffee, decoys, an' everything."

At 3:30 that afternoon, after a long nap, I call the Putman household. Mary picks up the phone. "Junnie's lyin' on the couch," she says. "The TV's on, but he ain't watchin'. No, he's sound asleep."

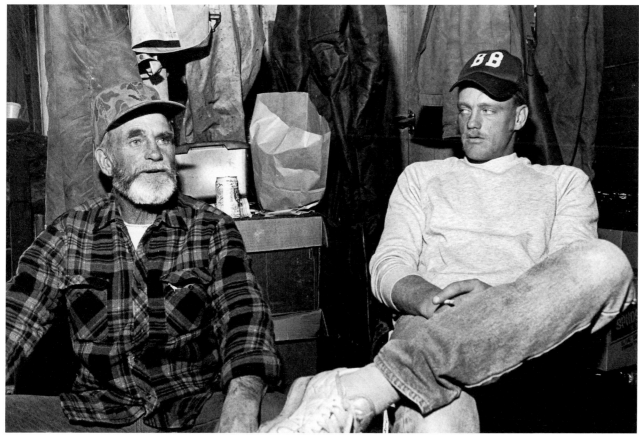

Junnie Putman *(left)* and friend Doug Griebel in Junnie's market after a day of fishing

You can have them big cities like Maquoketa or Savanna [populations around 4,000]. People ain't neighborly. Can't trust nobody. Dubuque? Ain't been there in forty years, buddy, except t'apply for licenses. Everyone lookin' to argue, don't get along; no one mixes like Bellevue.

We're friendly here. We help each other out. All peaceful. 'Cause it's a small town. But look out if she grows. Anytime you get above a couple thousand, it just ain't civilized no more.

—JUNNIE PUTMAN

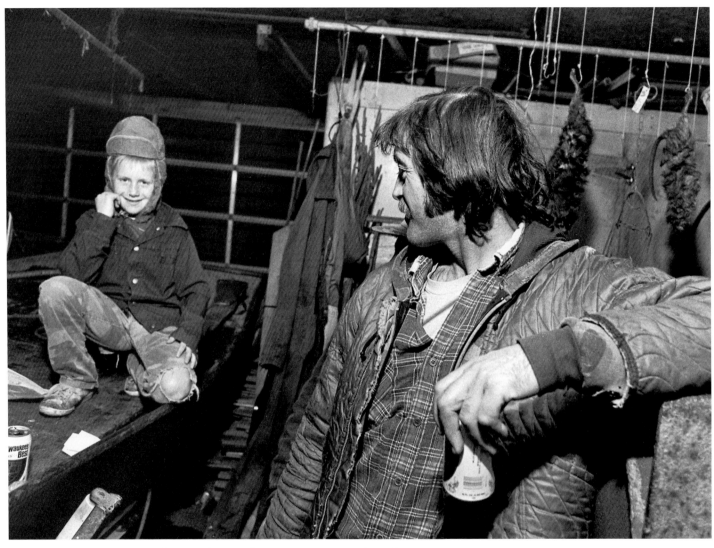

Little Dave Putman *(right)* with his nephew Rodney Putman in Junnie's market

Gosh, we lost so many these last years. Junnie's brother Ralph, two of his sisters, mine, my daughter's son, and of course our boy, Johnny. Oh, and he was comin' along so good, too. You know, from the time he was three Junnie took 'im fishin'. In cold weather he'd put blankets in a fish box, wrap little Johnny in them. Oh, how he liked bein' on the river with his dad! Or when Junnie run traps in wintertime, he'd slide little Johnny along atop the sled.

When he was killed outside of town in a car wreck, we was so heartsick, all of us, but Junnie took it hardest of anyone. But when our grandson come along, why, Junnie took him in, adopted him, no matter him bein' born out of wedlock Mike was. Just like our John, he took him on the river, taught him how to fish and hunt. Oh, they was close as two peas in a pod, those two. So like our boy, too: respectful, hard workin', resembled him in features and in build. Maybe that was how Junnie forgot the pain of Johnny leavin' us.

But then that come to an end as well. Our daughter phoned Junnie one night to say that Mikey crashed below the St. Donatus road. There'd been a mix-up pickin' up his girlfriend; he thought she'd left a wedding reception, but was only changing dresses in the bathroom. That kinda finished Junnie for some time. He started heavy with the drinkin' then; not that he hadn't hit the bottle earlier (show me a commercial fisherman that don't), but after that it got the best of him; you see how skinny he's become, not bull-chested no more like his brothers Rich or Davey. Oh, he won't start until he's off the river, give him credit there, but every night the beer and highballs knock him out. "To stop the pain," he says. 'Cause otherwise he couldn't stand it.

—MARY PUTMAN

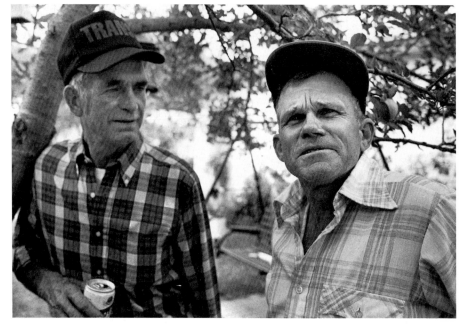

Junnie *(left)* and friend Roger Keil, a local farmer, at a family get-together

Junnie: Government spent all this money diggin' out the slough to make a refuge. But then they find out the ground's so sandy it won't hold no water.

Roger: I dropped by their office last month. "Tell you how to fill it up," I says. "Get all them state workers to stand on the bank and piss in it." Oh, they didn't like that.

Junnie: They always got a study goin'. Then they start another one to see if the first was any good.

Roger: All those Ph.D.'s they got workin' in there. I told 'em what they oughta do is buy a six-pack and sit down with some of these boys that's worked the river all their lives, like Junnie. You'd get a pretty clear picture from 'em. Oh, they didn't wanna hear that. Now they see me comin', everyone runs to the computer hookup or they're all of a sudden talkin' long distance. Hell, they ain't had a phone call down there in two years.

—JUNNIE PUTMAN AND ROGER KEIL

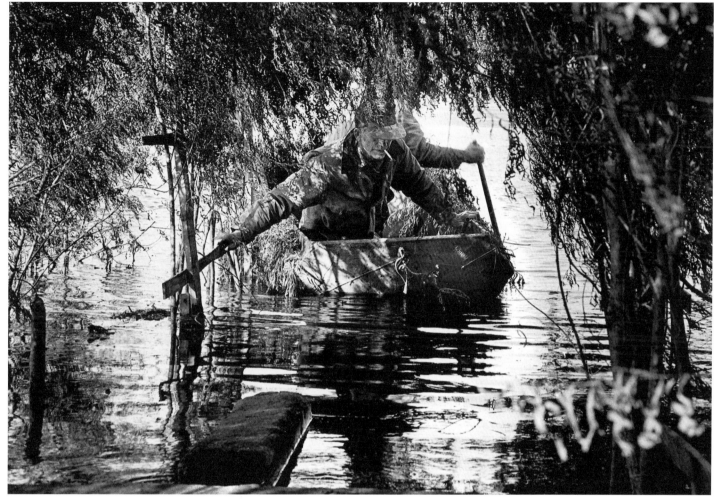

Junnie *(foreground)* and brother Richie pushing off in a willow-covered boat, enabling them to sneak up on geese

You gotta move in real slow, make 'em think you're a log. We float in so quiet sometimes I've had mallards paddle out and take weeds right off the side of the boat. Oooh yeah.
—JUNNIE PUTMAN

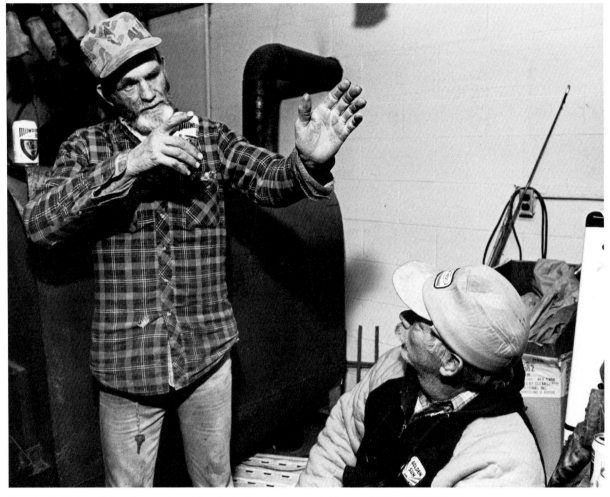

Junnie *(left)* describing the results of the day's deer hunt to neighbor and friend Cliff Ennis

Richie: That your deer, June?
Junnie: Yep. Hit him fo' out of five at 118 yards.
Richie: How'd you know it was that fuh?
Junnie: I paced it off . . . long steps, too!
—RICHIE PUTMAN AND JUNNIE PUTMAN

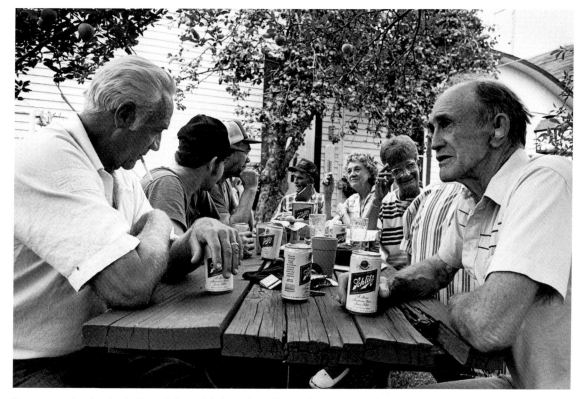

Putman gathering including *(left to right)* Herbert "Junior" Hall, Junnie's cousin; Gus Glasser, Junnie's neighbor; Raymond Putman; Junnie; Grace Steines; Pauline Hall, Junior's wife; and Big Dave Putman

We was trammel nettin' one spring when all the bottoms was flooded. High water. Makin' sets, you had to get out of the boat and wade. I was backin' up, gonna tie onto a tree, and I hear this noise behind me. Look over my shoulder and there's a badger settin' in the low branches. All hunched up and ready to spring, he was. *Hisss.* I drop that net and took off, run straight for shore, don't look back once and only stop when I get to the truck. Oh, them badgers is mean; pound for pound they got to be the fightin'est animal they is, unless it's a wolverine.

But he was stranded in that tree, the only high ground he had; that was his territory and he was gonna defend it. [If] I had a taken one more step, he woulda got me. Leapt right for my throat and chewed it to pieces. Lucky, boy. You're goddamned right I was lucky!

—RICHIE PUTMAN

Junnie getting a haircut from daughter Peggy Hayes in her shop prior to attending a wedding

If someone wants to learn about the river, he's the first one they come to. . . . 'Cause no one knows more than him. And you seen him with Clyde Pickert [a neighbor], the one who got so sick after he lost his wife. A great big fellow, wouldn't eat none, almost come down to skin and bones. 'Member how Dad took 'im out on the river every day, showed him nature and stuff when he was fishin', made 'im laugh and stop feelin' so sorry for himself? And after a month it got so's a gang couldn't pull Clyde from the dinner table.

Then just look where he found his dog: out by the islands where someone had left her to starve, poor thing. But Junnie took her in and treated that animal just like he'd paid five hundred dollars for it. Yeah, always nursin' the strays, everybody says. Although don't look for no charity if he ever finds the one who abandoned Queenie by the slough.

—PEGGY HAYES

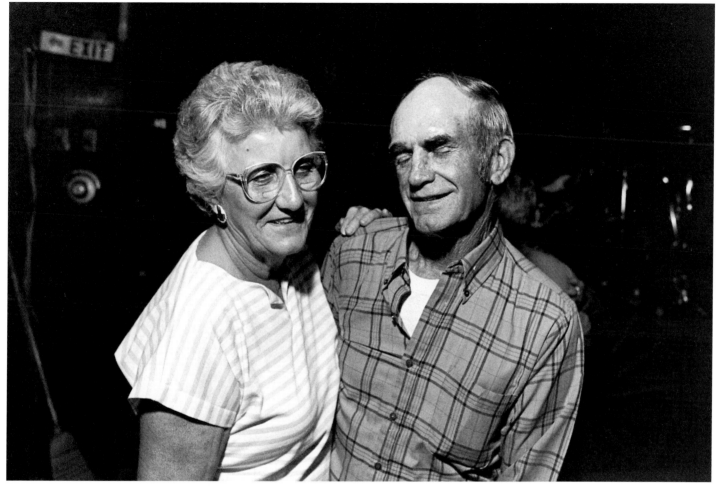

Junnie and Mary Putman dancing at Mooney Hollow, a barn converted to a bar and dance hall south of Bellevue

I still love him, but it's different today. Used to be there wouldn't be no swearin' around me. If we was out drinkin' and someone used profanity, why Junnie'd knock him to the floor. Now you hear the language they use in the market every day!

—MARY PUTMAN

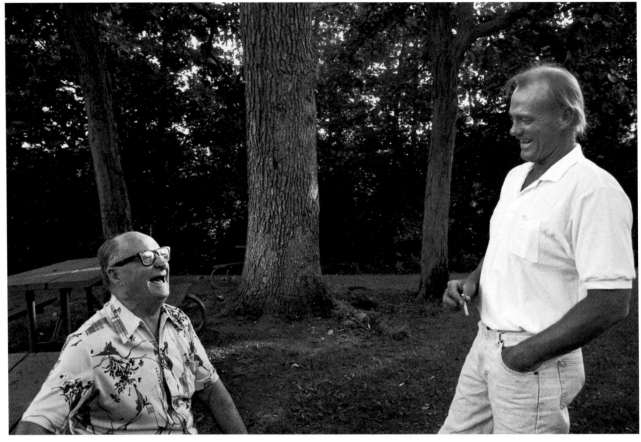

Vinnie Putman *(seated)*, Junnie's cousin, and Doug Griebel reminiscing at the Putman family reunion during September

Little Dave: Hey, 'member that time Johnson was on with us at night?
Junnie: Oh, yeah, Jesus! When we dumped him overboard.
Little Dave: He had to take a crap, see, so Junnie run him in to the bank.
Junnie: We was idlin', but the motor died on me, shut off all of a sudden.
Little Dave: That quick stop felt like we hit the bank, so he stepped off.
Junnie: Sploosh! Ol' Johnson walked right in the water.
Little Dave: He didn't have to go after that.

—LITTLE DAVE PUTMAN AND JUNNIE PUTMAN

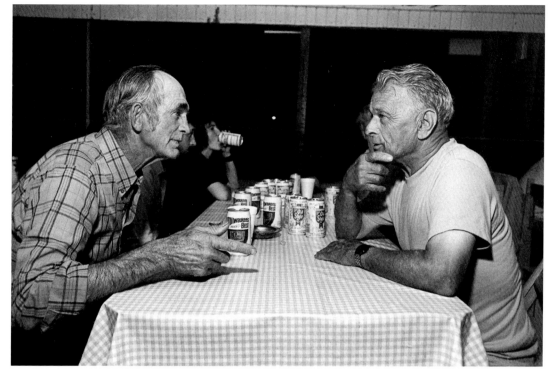

Junnie *(left)* and his cousin Eddie discussing the state of commercial fishing today at Mooney Hollow

When I was twenty, I lived on an Indian reservation in North Dakota for seven years. Oh, those people are really special. Today I read every book I can get my hands on about 'em. No, boy, you can never teach me enough about the American Indian.

One day we drove way into the back country, and just where the road ends we come across this little restaurant. Went in for coffee and at one of the far tables, sittin' all by himself, was this old Sioux, had to be in [his] eighties, all dressed up in full regalia. Oh, I wanted to talk to him in the worst way! Sat there for about ten minutes thinkin' about which dialect I'd use, 'cause lot of the old-timers wouldn't learn English. I finally walked over to him when I had what I thought was an intelligent question all worded out, oh, what a dignified old man he was! Stood at his table and just before I got out the first word he looked up at me and said, "You think the Braves will win the World Series this year?"

—EDDIE PUTMAN

You should see the Christmases we have. Besides us, Mom and Dad have everyone from Bellevue that's alone come over. Anybody that's sick or their wife or husband just passed away or maybe their spouse is out of town, they're all welcome to spend the day, same as family. From breakfast 'til the last lump of stuffin's gone.

—PEGGY HAYES

Junnie's daughters, Peggy Hayes (*standing*) and Tami Purvis, and granddaughter Michelle Purvis at the family block party in mid-August

I used to think the river was a wonderful place,
all the beautiful sunsets and colors, clouds.
But after our Johnny died, I'd only go out a little
bit, and of course when my grandson passed away,
not at all. See, I associated it with them, it bein'
such a big part of their lives. Then it just became
a depressing place for me. God, some days I can't
even look at it.

— MARY PUTMAN

Tina Baxter, Mary's niece, who did not marry a fisherman, getting
into a van after her wedding dinner near Andrew, Iowa

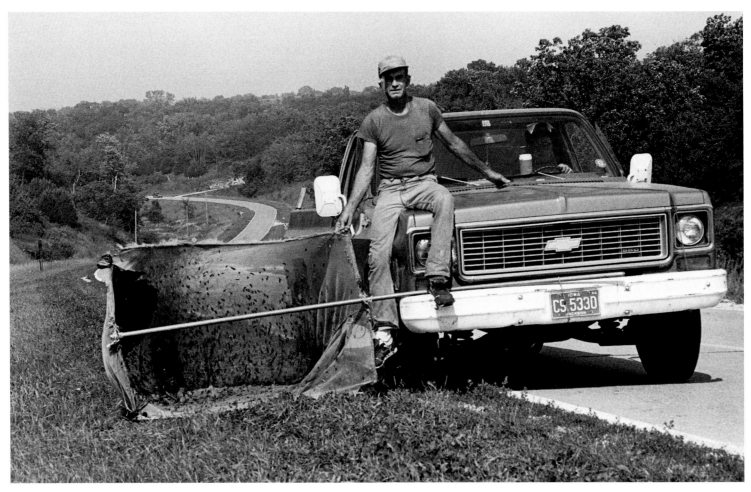

Junnie Putman holds a contraption that will net grasshoppers, used for bait, when they are
flushed from the roadside south of Bellevue.

8 Trotlining

An anchor begins the trotline's three-hundred-foot length, and a bright locating bobber—usually a plastic quart-sized antifreeze bottle—concludes it. Dangling from every sixth foot of its thick cord is a "staging," ten inches of twine, a swivel, and a number three hook small enough to gaff a two-pound catfish but large enough to lip another fifteen times that weight. When ready for "setting," the thicker cord is coiled on the bottom of a wooden box, fourteen inches on each side and three inches high, with two inches of twine and hook notched and dangling outside the box. Impaled upon each of fifty hooks dangles whatever delicacy might suit the fickle catfish's palate.

Since fish cannot survive a half hour in Bellevue's chlorinated water, Junnie and Richie begin the trotlining cycle at the state park, south of town. There, as they fill their 150-gallon tank with untreated water, they are joined by the park's attendant, Cecil Tooley. "How long you think this weather's gonna last?" asks Junnie.

"'Til it changes," says Cecil.

"Gonna be a mean winter," continues Junnie; "squirrel coats is so thick you can hardly skin 'em."

Water in tow, they drive a half mile to Roger Keil's farm where they will collect the first of two kinds of bait. Actually, they are reaping the fruits of last May's labors, when in some shaded backwater they cut down two hundred reeds, each dotted with fertilized carp egg. Tossing this harvest upon the surface of Roger's unfed pond, they created their own bait shop, for the hatched fish, shut off from all but the most meager nourishment, grow to only an inch and a half or two.

Standing above this pool, the Putmans unroll fifty yards of fine meshed seine. Richie grabs its pole at one end and, groping his way down the steep bank, wades the mesh across the pool with Junnie then joining him at the water's near side. Now together, they drag the seine across a third of the pond's length, lifting boots out of muck with every step. At last they collapse the net ashore and from it pour some seven hundred carp minnows into a quart-sized jug. Then, regaining the bank once more, they pour the bottle's contents into the 150-gallon tank and snap on its aerator.

To begin the next operation, they return to the road and climb a low ridge. From there they alight and unfold a fine mesh net, about five feet by four feet, held open by metal rods that they insert around its edges, then lash all to their pickup's front. With Junnie seated upon the hood, steadying the top of this quixotic contraption, they start up, the two passenger side wheels riding just off the pavement. From a distance, the truck may be mistaken for a landlocked sailboat riding drafts that sweep the Iowa hillsides.

In motion now, the net scrapes the grass top, flushing most of the sunning grasshoppers who, startled, fly up and forward a few yards before falling back, snagged on the advancing mesh. Some two hundred yards down the road, Junnie and Richie stop and fold the net and guide its contents into a large jar. Shaking the container for thirty seconds, Junnie says of the armored bodies slamming into glass, "Sounds like popcorn."

Back at the market, they place the bottle in the freezer and wait for the insects to numb up further for easy handling. Sipping coffee, Richie says that maybe they ought to sprinkle Roger's pond with soy meal so that the bait carp will grow larger, thus luring larger fish to their lines. "Don't make no difference, Richie. They gonna quit feedin' for the year pretty soon."

"Well, how 'bout next year?" Richie persists.

Soon after, they begin baiting every alternate hook that dangles over the side of the trotline box, spearing each grasshopper through the mouth and out the stomach, saving the empty hooks for minnows. But even with Rodney Ehrler's assistance, the task consumes an hour and a half.

By 5:30 P.M., the three are on the river, splashing towards their first location. As Junnie runs the boat, Richie scoops handfuls of minnows from the large tank and places them in an inch of water in an aluminum drawer, pirated from below the sink in a wrecked boat's kitchen, from which they are easier to retrieve. By the time all the hooks between the grasshoppers are baited, Junnie is close to the river's Illinois side. He places the trotline box beside him and idles the motor, then tosses over the line's anchor, known as a railroad creeper. Years ago, these question-mark-shaped fasteners were driven atop a rail's flange, holding it in place during extreme temperatures, when it might drift. When old track was replaced, Junnie appropriated scrap piled along the line.

Now he moves away slowly, each putt of the motor nearly indistinguishable from the previous one. Out of the box fly line and hook, but with such rapidity that they deceive the eye. Instead of a succession of fifty hooks, one after the other, they spinningly appear as one, resembling a poised cobra: the hook is its head; the whipping twine beneath is its body. With the outboard's tugging, the hooks can fang as deeply as a rattlesnake's. That's why as each row of hooks runs out, Junnie gingerly turns the box so that the next one's contents face the back of the boat from which they, in turn, might jump into the foam. "One of 'em bites into your thumb, you gotta push it through the other side. 'Cause if you yank it back they'll tear the shit out of your tendons." Finally, when all three hundred feet play out, he tosses in the bobber.

Two more sets are placed out in deeper water, three on the Iowa side close to shore, and two in deep water off an island. Richie and Rodney hurriedly bait carp minnows to keep up with Junnie's restless pace. Even he, while running the boat, tiller tucked under an arm, stabs a few pieces of bait onto hooks.

Usually Junnie, aware of the general location of the fish, would be setting most of his lines in either deep or shallow water. But after four days off the river, having had cancerous skin peeled from his face, he must hedge his bets. He wonders if the water has risen high enough to tempt schools inshore for feeding. Or has it been low enough long enough to overheat the water, sending fish to the depths where they can fin more comfortably? Worse yet, did a storm spook them into one of the sloughs or backwaters? So until he can answer these questions, he must test different locations.

Incidentally, this phase of trotlining is dictated by the feeding schedule of the "billy gar" or short-nosed gar. Nearly impossible to snag, this voracious eater would strip most hooks clean of bait before 5:30 P.M. So to avoid merely setting out a banquet, Junnie begins after 6:00 P.M., as the sun begins to paint its deep pastels upon the Illinois bluffs, and finishes some twenty-five sets later, when the stars shimmer above Bellevue's north palisade and the Putman market is shrouded in dusk.

A faint glow paints the sky at 5:30 the next morning as Junnie pushes his boat into the water. Half a mile downriver, he spooks a great blue heron, which rises from its roost and paddles around the island. "There's old Jimmy Crane," croaks Junnie, calling out the bird's local nickname. A hundred yards upriver, a dozen sandpipers skitter along an island's narrow beach, bobbing up and down for worms or crabs in the soft sand. "We call them teeterasses," says Junnie over the outboard's cough, our approach scattering them into the air. A number of other bird species have local nicknames. The occasional cormorant is a "black loon," the lesser scaup goes by "black jack," goldfinches are known as "yellow canaries," and the European tree sparrows are referred to as "spotsies."

Junnie is a different person from the one of the previous night. For then, after a dozen beers and a shot or two, he seemed to shrivel up inside himself, growing smaller and smaller. Peevishly he gave his views of river and woodlore, challenging others to contradict, snapping at those who did. But this morning, after six hours of sleep and a jolt of coffee, he sits ramrod straight while glancing at the sky above the river, chest thrown back, eyes clear. All opinions and knowledge are proffered with good cheer and generosity.

A mile ahead, he cuts the motor and drifts toward his first line. With craft in motion he walks its length and, bending over from the bow's upraised deck, grabs the bobber. Into the boat it goes, and Junnie begins to pull in the line. Momentarily, a naked hook breaks water, then another and another, then a fourth with only part of a grasshopper dangling. "Little bitty ones is doin' that," he explains, and two hooks later the evidence, a nine-inch channel catfish, wriggles from the line. "Could be a slow day," he says.

Next he frowns at the three-pound drum, since it brings in only thirty cents a pound compared with the catfish's sixty-five cents, but cheers somewhat at the two four-pound "flatheads," a larger variety of catfish, near the end of the line.

Each of these is coaxed alongside the boat and landed with a dip net. Then carefully grabbing the catch between gill and dorsal cartilage, Junnie removes the hook. "Gotta be careful," he says of the sharply serrated edges. "Get stuck by one of them, nothin' you can do; just go see the doc and have him push it out the other side. Draw it straight back and it'll tear your tendons, just like the hooks."

Junnie's hands blur as he spools in each line. Even vegetation clinging to it hardly slows him. For large growths, he plucks as if shooting a short arrow, and for smaller ones he merely strums his hand across it, jettisoning the weed either way. In between, he jerks up his head each time the faint honking of Canada geese reaches his ear. Finally, he removes a board from behind him and tosses all fish caught into the hold below it before returning to the tiller.

The next two lines, grouped off a wooded island, are more bountiful, each yielding a half dozen three- to four-pound catfish. The sun is now well above the treetops on the Illinois

side as he scoots to another line. On this one, about the fifth hook, Junnie flips a fifteen-inch fish onto the deck. On its back, the creature resembles a small shark with its whitish belly and rounded jaw with mouth underneath. "A hackleback," says Junnie, giving the local name for the sturgeon. "Got caught in the side. They's always swattin' at logs with that spiny tail of theirs. Knock off a crawfish or somethin'. Got hooked when he tried it with the grasshopper. Last spring me 'n Rodney had a run on 'em out by Kennedy [Slough]. Cleaned 'em all day right in the boat and made more than seven hundred dollars between us. But they's good eatin'. Smoked. Oooh yeah. Won't taste nothin' better on the Miss'ssippi."

Although Junnie works close to thickly wooded shores, hardly a cry reaches our ears. Only a solitary heron squawks every quarter hour as he arrows down the channel. But for him and the occasional fish breaking the surface, torpedoing a dragon fly, the Mississippi seems a primordial soup, yet unsuspecting of life.

On line number twenty, water boils suddenly around the boat. "This is a good-sized one," shouts Junnie. Quickly he uncoils twenty feet of line from the box, snipping off its three hooks so as not to get barbed. *Thwip!* Downward plunges the line. "Son of a bitch!" shouts Junnie, tugging slightly as the line plays out. Then five minutes later, he boats the eighteen-pound flathead. "Not my record, but he'll feed a few. 'While back I hooked an eighty-four-pounder. Took fifty minutes to get him in the boat. Had to cut seven hooks to play him out."

More housekeeping is done astern, in front of the motor. Between draughts of coffee and tugs on cigarettes, Junnie stacks his trotline boxes. Piles of de-baited empties are continually broken down and rearranged in pairs or piled seven high, these arched perilously toward the water and stepped like an Aztec pyramid. Sometimes, in a five-minute operation, he uproots the boat's planked bottom to start tightly packed piles against the boat's sides in order to widen its walkway as much as possible, which is critical. Striding full tilt along the moving craft, it is easy enough to get snagged by a hook, trip, and possibly topple overboard. There, burdened by waders that gulp in water greedily, one could possibly drown.

Only three more lines to raise. Junnie motors more slowly, perhaps stretching his time on the river an extra few moments. Other than three years in the army and one each as a lumberjack and Corps of Engineers employee, he has always fished these waters commercially since the age of fourteen. This part of the Mississippi, with its islands, sloughs, and tributaries, brings back a flood of memories to him. A buoy we motor past recalls a sad occasion. "That's where we lost my brother Ralph," he begins matter-of-factly. "One Sunday he was workin' the barges, went to the back of the tug to take a leak, fell off, and was chewed up in the propeller."

Scooting through the slough, a patch of reeds evokes a happier event. "Me, Ron, and Tami was settin' lines along this island, and just as we pulled out, somethin' started to cry. Sounded more like a baby than a wild animal, so I cut the motor and let us drift. Well, pretty soon the reeds broke, and a second later here she come runnin' through the weeds, just a pup and nothin' but skin and bones. Swam up to the boat, and when Ron lifted her in, she jumped and kissed him all over the face. Kept on and on. Wasn't she glad to see him! Right, Queenie!" he says to his suddenly appreciative pup.

"Someone abandoned her. And we call animals cruel! A bitch would never do a thing like that. I'd trust a dog before a human bein' anytime. Oooh yeah!"

As Junnie backs his truckload of fish into his market, his brother Richie waits for him. "How'd you do?" he asks.

"All right," says Junnie.

"Don't look like you did too good," says Richie.

"Can't catch 'em all in one day," replies Junnie.

"Well, Anderson caught lot more than that . . ."

"Well, he's a better fisherman than me," says Junnie sarcastically, for Junnie is accorded to be one of the top fishermen who raises nets along this stretch of the Mississippi.

Richie tries another tack. "What's the weather supposed to be tomorrow?"

"I ain't listened yet. You wanna help me out?"

"They say a chance of storm; might spook 'em back into the sloughs."

"Jesus Christ, Richie!" Junnie explodes. "If it ain't too hot then the wind's too high, the ice ain't thin, the water's risin'

too fast. Always some excuse. How many fuckin' fish you ever caught while drinkin' coffee in your livin' room? Huh? Answer me that!"

Acrimony seems to hang in the air for a short while but then blows away when the oldest Putman, Clare, age eighty-six—once a commercial fisherman—pays a visit. As Junnie skins and guts his catch, they reminisce a while, swapping stories back to the 1930s. Then during a long silence, Junnie realizes, "Yep, commercial fisherman's day is almost done. None of the young is takin' it up. Someone I won't mention was a good worker, but he wouldn't stick with it. You gotta go out every day, follow 'em, see if they's feedin' in close or out in the channels. Never know what's gonna scare 'em off: water fallin', change in temperature, rain, wind. But this fellow would take a day off and lose track, have to waste time findin' 'em again. Keep after them fish, right, Clare? Like Poppy said, 'Commercial fisherman's gotta pound, pound, pound!'"

92

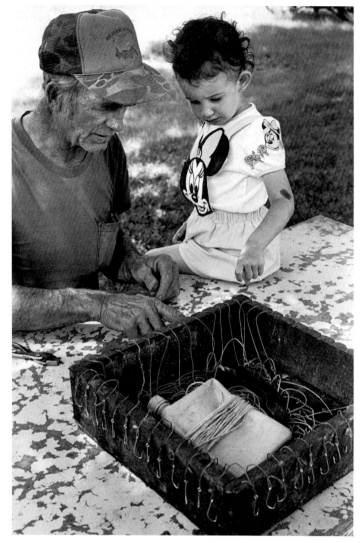

Junnie Putman replacing hooks on his trotline during the first week of June while his granddaughter Michelle Purvis watches

We lost a little girl 'while back. Smothered in her crib, she did. Thelma was with her at the time, workin' in the garden. She heard the baby cryin', but didn't pay no attention to it at first, you know. When it kept on, Thelma thought she needed another pillow 'cause she was stretched out kinda flat. By the time she come back out [to] the house, the baby was layin' there, dead still. Suffocated. Took her to the hospital, but there was nothin' they could do. I was on the river at the time. She come and got me, but by then it was too late, you know.

That was thirty years ago. Thelma changed after that. Used to be a sweet person, but now you see how she snaps at people sometimes. Yeah, we had another girl and a big family, seven in all, but since that day in the garden, she's been a different person.

—BIG DAVE PUTMAN

Pesticides killed all them birds. While back when we seined for crawdads, you could fill a five-gallon washtub in a half hour. Now we cast all mornin', maybe net a couple pints. But in '88 with the drought, they come back strong as ever. Get many as you want. See, wasn't any rain to wash chemicals in the creek. There's your proof.

—JUNNIE PUTMAN

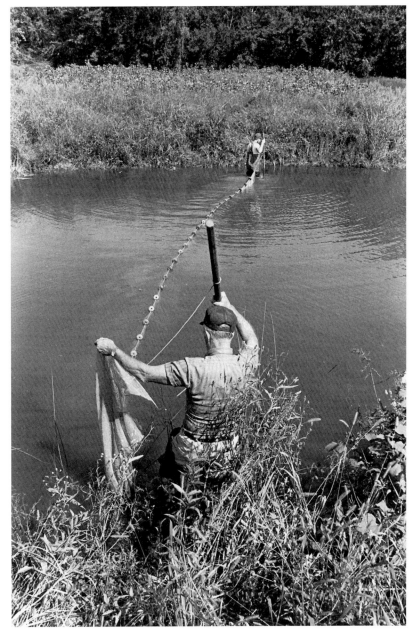

Richie Putman (*foreground*) and Rodney Ehrler stretching fine meshed seine across a pond to capture carp minnow for bait

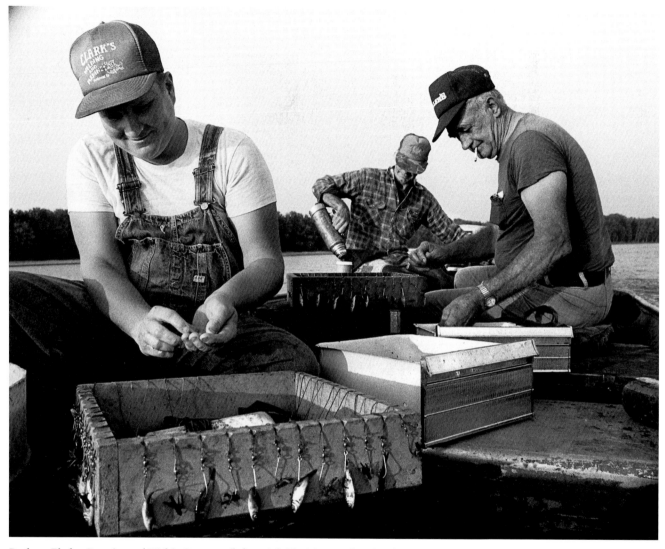

Rodney Ehrler, Junnie, and Richie Putman *(left to right)* baiting trotline hooks with carp minnows at about 6:30 P.M. south of Bellevue

Fish with another man and it cuts into your pocket, but work alone and you can shove it all in there.
—RICHIE PUTMAN

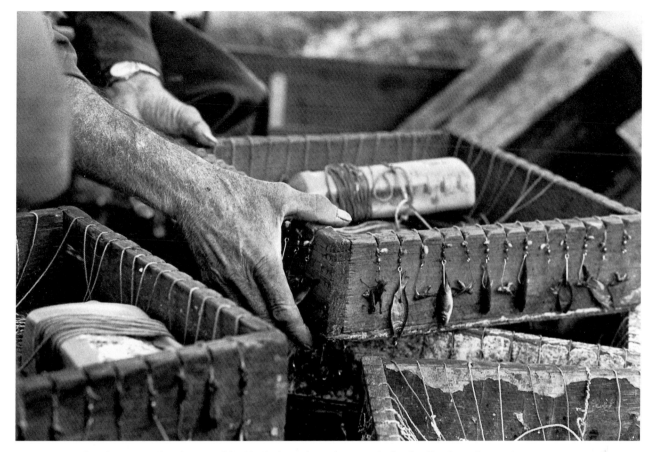

Junnie gingerly taking a trotline box, its fifty hooks baited, to place on the back of his boat for casting

But that's the way it is out there. You're yankin' on them nets all day, tryin' to keep your balance, and then a wire or hook'll nick you. But you don't notice it. Come home, your face and arms [are] all covered with blood. Look in the mirror, "Jesus! I don't remember gettin' cut like this." Like workin' in a slaughterhouse.

—RICHIE PUTMAN

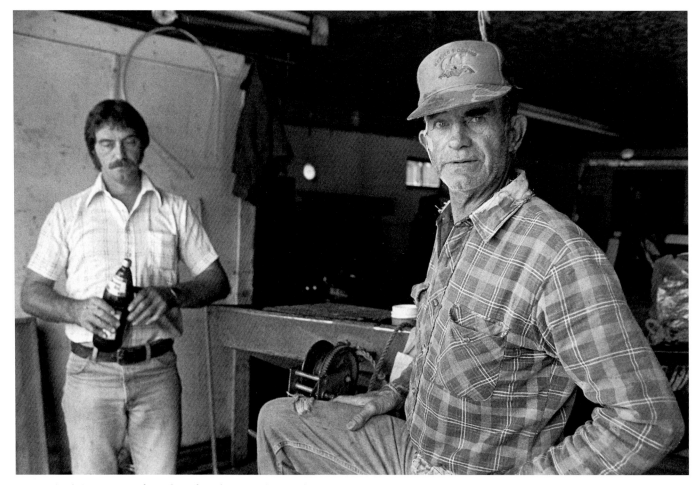

Junnie *(right)* preparing for a day of trotlining in his market while his nephew Little Dave visits

We had a game warden sent up here some years back. Wes Beecher.
Went strictly by the book; wouldn't give nobody any slack. That's
why they put a bounty on him. Oooh yeah. Down south a lot of
them game wardens walk into the woods one day, and that's the last
they ever see of 'em.

—JUNNIE PUTMAN

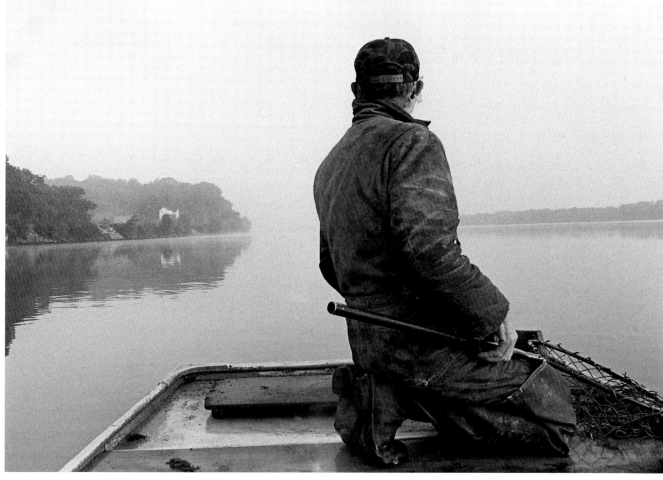

Junnie gliding toward one of his trotlines on the Mississippi River just north of Bellevue in early fall

We used to have these waters to ourselves, never see another man all morning, tugboat or barges neither. Just us and Mother Nature. Oh, it was peaceful, boy.

Now with all the pohliners around—Davey counted four hundred boats in one quarter-mile stretch—we ain't fished weekends in twenty years. It's more like the Indianapolis Speedway than the Mississippi River.

—JUNNIE PUTMAN

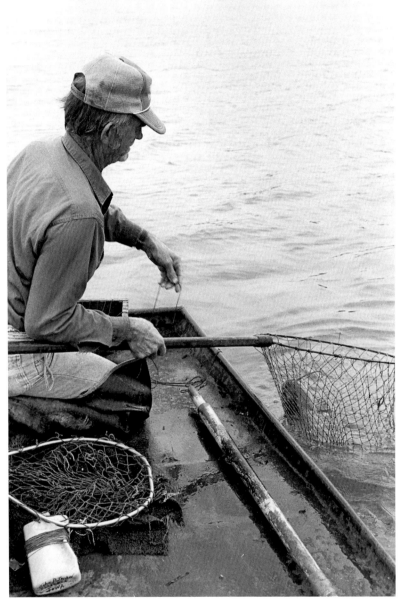

Junnie pulling on a trotline with left hand, guiding a ten-pound catfish into the dip net held in his right, the dip net in the boat being reserved for smaller fish

Grace: Why don't you quit fishin'? That cancer's gonna get you.

Junnie: Can't stop workin', Gracie, we got bills to pay.

Grace: Well, take a job indoors. You're still strong, could keep up with any of them young kids.

Junnie: Don't coop me up in no factory.

Grace: Then take Social Security and just fish two days a week.

Junnie: Gotta be on my river always. What's the point of livin' if you can't be with Mother Nature?

—GRACE STEINES AND JUNNIE PUTMAN

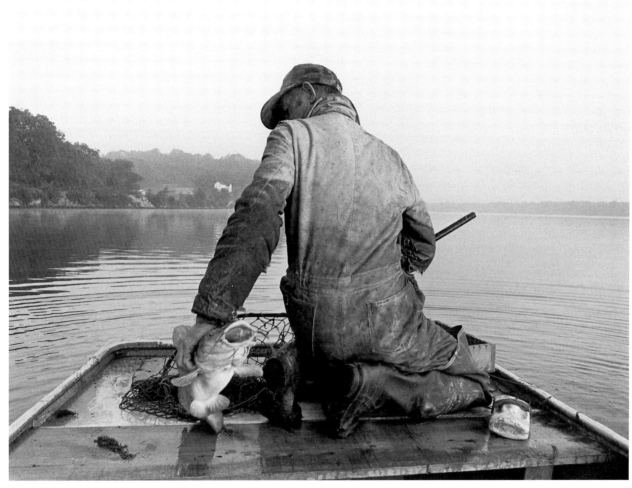

Junnie taking a catfish from his trotline with one dip net

It gets rougher than a cob out there. You wouldn't think so, lookin' at that little river, I mean compared with Lake Michigan or the Atlantic Ocean. But when a storm comes up, I'd much rather be on one of them bigger bodies of water that's got a rolling motion to 'em. 'Cause here the waves break so close together that when you ride out the first one and you're down in the trough, another's comin' right on top of you. And it don't take more than two or three to swamp her.

—STEVE PUTMAN

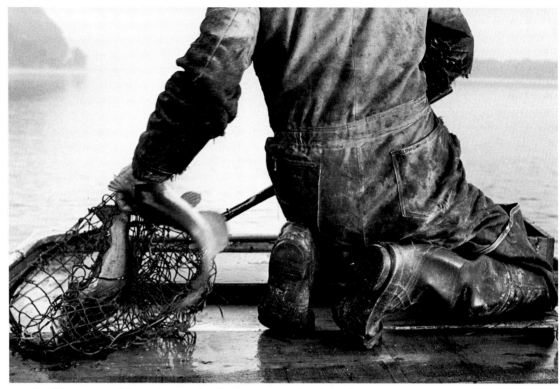

Junnie taking two catfish on separate hooks some two miles above the Bellevue Dam

You know how quiet chickadees is. With one you have to listen hard to hear 'em. Just a whisper. Twenty years ago, they ganged up by the thousands on the islands, covered every bush; made such a racket you couldn't even have a conversation. But now you don't see none of 'em no more.

And wild canaries, gold and yellow. Pretty. So many'd congregate along one branch they looked like Christmas ornaments. Hundreds. You don't see none of them no more neither.

Yep. Used to be lots of fishies and birdies swimmin' and singin'. Now they're scarce. Just like commercial fisherman, most of 'em is done. [Junnie refers to goldfinches as wild or yellow canaries.]

—JUNNIE PUTMAN

Last spring I come out of the slough and there was nothin' but fuel oil atop the water. S'all you could see from bank to bank. One of the tugboats dumped it. Had to be. They gotta empty out their tanks, only they ain't s'posed to drain 'em in the river. But who's gonna stop 'em? They run at night, and 'fore anybody knows what's goin' on, they's ninety miles downstream. I called the state biologists, tugboat companies . . . they said some barges come through all right, but you couldn't prove nothin' by it. Doesn't bother them none. Hell, they just need water to run on. They don't care what's in it.

—RICHIE PUTMAN

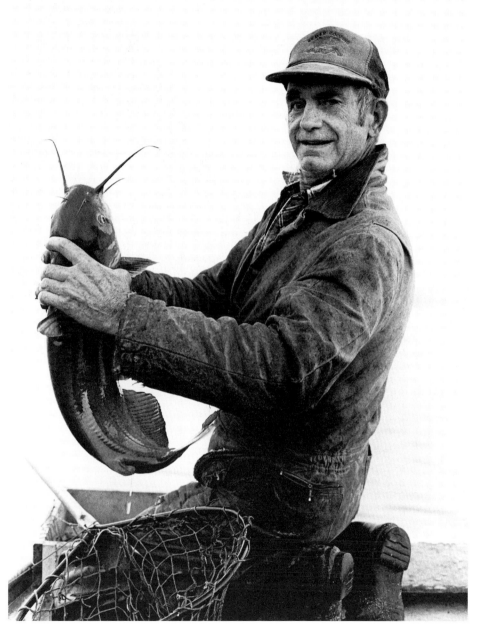

Junnie holding up a fourteen-pound catfish taken on a trotline

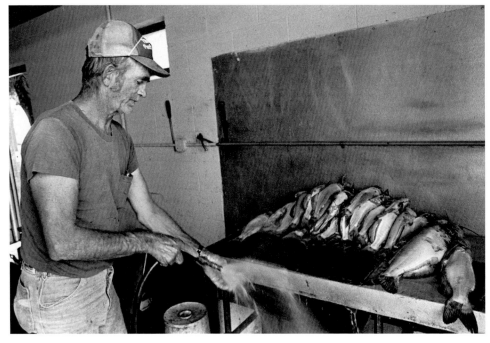

Junnie washing himself and dressed catfish in his market at the south end of Bellevue

Old Uncle George was a son of a bitch. One time when I told him we didn't get enough for fish, he slapped me 'cross the mouth. I mean we was doin' all the work; he just called the buyers. I says, "If you wasn't such an old buzzard, you'd be sittin' on the floor right now." Then one of his helpers punches me in the jaw. So we go at it, but hell, I fought professional six years. I was roughin' him up pretty good when this other fellow swing a crowbar at me. He missed, but the breeze about parted my hair, he come that close.

Back home I run into my brother and he says, "Aw, don't worry about it. I'll get your fish boxes back." Half hour later, I see his truck come down the road, weavin' back and forth. They'd gotten into it, see; one of 'em took a claw hammer and raked open the whole top of his head. Jeez! The blood was gushin' out of him! I run him to the doctor's office by the lock and dam. He took one look and says, "Have you all been fightin' in the south again?" I says, "Yeah." "Well, I ain't gonna take care of you," he says.

So we go back home again. I had to shave all the hair off his head [and] close the wound with duct tape. Say, them was the days, wasn't they!

—EDDIE PUTMAN

Highback and carp attach their eggs to reeds, but hackleback'll lay 'em in the sand. Then tugboat comes along, stirs up the ground, and covers 'em with mud. No sturgeon's spawned 'round here in twenty years. The government ain't figured it out yet. The stupid Feds come snoopin' 'round above the dam, below the dam, around the flats, can't find no signs.

Just travel up the smaller streams where barges can't navigate, the bottom's undisturbed, [and] on any Sunday afternoon you'll see a hundred people standing on the banks, scoopin' out sturgeon by hand. And there's your spawn.

Learn wildlife habits by observin' nature, not by readin' books or studyin'. I know lot more 'bout fish than any fuckin' biologist.

—JUNNIE PUTMAN

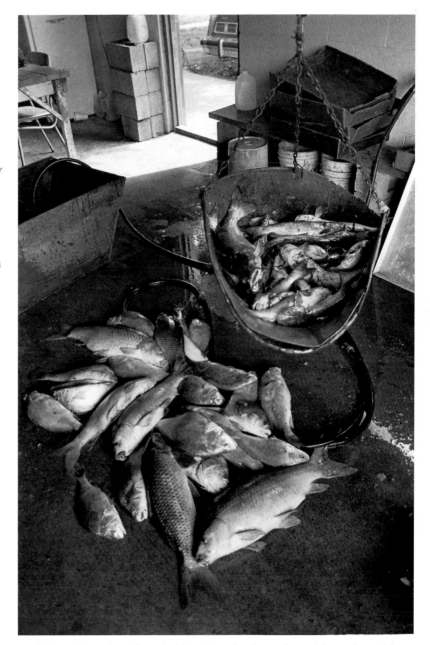

Catfish on the scale and perch (drum) on the floor of Junnie's market, with fish boxes in background against the wall

Peggy Hayes stands by as Don Helms and Craig Anderson haul away seine, purchased at the auction of her father's estate in late September 1998.

9 Passing of a Fisherman

It is May 1997. Junnie Putman leans his rifle beside a dead oak. From this post, he commands a view of the valley below him. Arching his back against the tree's trunk, hardly winded despite climbing a series of hills, he uncorks his thermos. As the wind sighs through the pines, he can still take satisfaction that at age sixty-nine, he outwalked the other hunters who are twenty, even forty, years his junior. Why, Rodney hadn't even reached a neighboring rise. At this Junnie almost smiles, scoffing under his breath.

As he listens for the first sound of turkey, a cooling breeze swoops down from the north. As his perspiration dries, he feels a twinge in his side. Probably the cold. He rubs the spot, but its numbness remains. Uncomfortable, he shifts his weight slightly, but like some determined imp it hangs on, biting deeper and deeper. He pours from the thermos and drinks, but coffee won't medicate it either. No, the cancer that will kill him in five months has set in its deadly hooks.

By mid-June, he is virtually housebound. Occasionally, he gathers his strength and shuffles out to his market. There he pokes among nets or trotline boxes, planning for his next day on the river, hoping the current round of radiation treatments might shrink the tumors that sap his strength.

But reality sets in. When old acquaintances call to cheer him, he invites them to come over. "We'll take a ride on the river," he suggests, then adds the cautionary, "No fishin', though." With his pain—at one point it is so bad he can't lie down for forty days—and the morphine's stupefying effect, even a simple pleasure excursion is out of the question.

As Junnie weakens by the day, unable to swallow much food, people from all over come to sit on the patio with him. "I didn't know I had so many good friends, Mom," he tells Mary. But sometimes company comes in relays, and for each new arrival he sits up for a few extra minutes before excusing himself, exhausted, to go to sleep.

One morning his niece Dianne Gunther, Don Helms, who had trapped turtles with Junnie over the years, and longtime friend Doug Griebel chat with Mary as they wait for the old fisherman to waken and join them. In the still, thick air, Dianne reminds everyone how Junnie "took in so many of those young boys over the years. Some of them didn't even have a father; didn't matter, he showed them how to hunt and trap and fish. All them boys just idolized him, followed his ways. You could say he raised them. No telling what would have happened if he hadn't shown an interest in them. There was Billy Reistroffer, Doug here, my brother and even one of his boys now. Look how they all turned out."

Now Junnie, with some effort, comes out and settles into a chair before putting the oxygen plug into his mouth.

"They was just sayin' how you showed all them young kids how to hunt and everything," says Mary.

"Oooh yeah," whispers Junnie, his eyes searching far in the distance.

Don Helms teases Junnie, "Of course I was younger than you; I had a lot more years to support a family. I couldn't be givin' away too much to ones who might be competition."

"No more secrets," says Junnie, clamping down his jaws.

"God," says Mary, "I remember them days when you'd go off on the river and tell me not to raise the blinds. 'Let 'em think we're sleepin' in,' you'd say."

"Otherwise they look for you, find out where you're makin' hauls!" says Junnie, his eyes flashing momentarily.

"Didn't even want the lights on . . . I used to stumble 'round in the dark some days 'til you got back."

A few minutes later, Junnie rises slowly and returns to bed. After a silence, Doug says to Mary, "Wouldn't let you raise the blinds, huh? I never heard that one. He's a sly old fox!"

On October 3, a wake is held at the Kingery Funeral Home in Bellevue. Near Junnie is placed two pairs of his waders. Against these lean two photos, one of Junnie that Mary had taken forty years previously, a portrait without the lines of character acquired by the more recent man. Inside the open casket, sallow, Junnie lies in uncharacteristic repose.

In the outer room stand two boards, three feet by three feet, covered with dozens of family snapshots, some recent, others going back to a more bountiful time. One shows Junnie, Big Dave, Richie, and Orville Steines holding up a quartet of sixty-pound catfish caught that day, more jumbos than Junnie has boated in his last three years. We see the Putmans and friends at parties and dances, at work in the market and in their boats. The entire display is draped with a trammel net's gossamer filament.

Later, a dozen or so people rise to remember Junnie before an assemblage of one hundred souls. Mary, Peggy, and Tami, along with several townsfolk, speak movingly. I recalled how on one autumn day, Junnie would glance up from raising nets and identify migrating ducks from a great distance; when they got closer, Junnie would comment on how flavorful the species was. I—a city fellow—thought I would try my hand. Pointing to an object lying low in the water, I had said, "That's a merganser, isn't it?"

Junnie had squinted ahead at the sunken log, whose crest barely cleared the surface. "That's a snag, Rich," he had said, and then reaching for his last hoop net added, "be pretty tough to chew."

Everyone mingles now, former fishermen, lumberjacks, farmers, and their wives. The women dress formally, many in black. A few of their spouses wear suits, though many others are clad in shirt sleeves, tieless. One of the old-timers hobbles with a cane; another ambles on crutches. All seem stunned. Only six months prior, Junnie had walked the neighboring hills and riverbanks and strode the length of his boat, yanking hoop nets from the mud or shore, grabbing clumsy and stupendous objects, or barking orders across bayous and bottoms to crew members less enthusiastic than he. Now he lies still.

The sun lowers in the west, its rays lengthening. Its light now filters through the window, filling the room with an appreciative glow. "God, the man could work!" says Doug Griebel. "I never saw anyone who could keep up with him. Even the old-timers, who were much tougher than us, he flat-out amazed them how he'd go and go.

"He knew it all, too. God knows I used to follow him around in them hills and bottoms like a pup, watchin' everything he done, hangin' on his every word. Oh, if he liked you, he'd share. Although I later learned some of his methods wasn't the best. Oh, there was easier ways. Didn't make any difference, though. The man was so strong, so bull-headed, he'd force it through, make it work better than anyone else.

"But you know, in later years I'd show him a trick or two, something different from what he taught me, stuff about trappin' mostly, and by God, he listened. I think he tried one or two out, and that was the ultimate compliment.

"And he hung onto the old ways. The man never changed from when he was forty, fifty, sixty; right up to the end he had his ideas. I don't know where it come from; not his dad, they wasn't close . . . maybe the time he lived on the Sioux reservation in North Dakota.

"Like just two years ago when me 'n a certain unnamed person got into it. He'd been sayin' stuff, some things he shouldn't. I told him to quit, he knew he was wrong, but you know how some people just won't let go of somethin'.

"Well, that night when we was drinkin' in the market, he started in again. I warned him, but he kept it up. So we went at it. I was gettin' him pretty good, although he got in some licks; oh, it was a regular bloodbath in there. Just then ol' June comes back from Wagner's [Convenience Store]. He picks up a baseball bat and cocks it, walks over to where we

was tusslin', but by then we move out of the corner so he's got no room to swing. Then he comes up behind and grabs me 'cross the face with them big hands of his, like catcher's mitts they were. He tries to pull me off, but I was pretty determined. Somehow I broke loose, though not before he tore a lot of flesh from my cheeks.

"So I went back to punchin' this fellow, oh, I hurt him, boy! Now Junnie grabs the bat again, but by this time the fight was over. Shit, the other guy didn't leave his house for three days, his face swole up so bad. Had Junnie and Richie bring him groceries and beer. And then he left town not long afterward.

"But if this guy hadn't quit just then, it would have been a different story. Rules was rules and strict was strict. I mean, to you or I, that structure was just cinder blocks, an old furnace, and some fish tubs, but to Junnie it was home. No fightin' in the market. And I'd crossed over the line, violated the code. One that went back hundreds of years to the first man who walked the woods with an ax. Because if that fellow hadn't squirmed under the boat, curled up like a possum, Junnie woulda killed me. I seen the look on his face when he choked that Louisville Slugger. You bet he woulda. Oh, I'm sure of it."

Next day, the Lutheran church on Sixth Avenue is filled. As all sit down, a ray of sunlight bursts through an ajar window, its beams splashing on the floor. Rev. Solveig Zamzow begins her farewell. Throughout the hour, she makes many references to boats, journeys, rivers. From time to time, she climbs down and sits while a hymn is sung, then returns to

the pulpit, limping noticeably. She speaks kindly in her thick Dutch accent, familiarly, too, despite having made Junnie's acquaintance only recently. Had some sort of bond formed between them during her consolatory visits? Did she know, this stern-looking but kind woman, could she know that Junnie always took the afflicted unto his bosom? The reverend pours her heart and soul into the text that day.

Outside, pallbearers wheel Junnie's coffin into the hearse and, after a brief ceremony, push it in. All go to their cars for the procession to the cemetery. Several former fishermen occupy the last car. Waiting for a quarter hour for the rest of the procession to start out are six men usually talkative, but as they sink into the soft upholstery, they are hardly able to say a word. While the engine idles, one finally murmurs, "It ain't gonna be the same in the south end no more." Others mumble assent. More silence eats up the time. "There wasn't too many like him," says another. All agree, those who were his partners over the years, those who walked the woods and shorelines with him. "No, he was the last; you'll never see his like again."

"That's for sure."

At last their car, too, moves out. Reaching Riverfront Drive, the men head south, paralleling the Mississippi, riding thirty feet above it. As all look eastward at the familiar waters, their minds swimming in memories, Orville Steines's bass voice booms out from the back seat. "You know how many muskrat Junnie could skin in an hour?" he says.

Billy Reistroffer, mum until now, spins around from his front seat. "Oh, a good forty," he says.

"Shit!" says Orville. "Cut off the head, run the blade up its gut, and punch through the skin. Before you know it, he'd have sixty pelts piled up in the market."

"One a minute. I ain't surprised," says Billy.

"Many times as I saw him do it," continues Orville, "I never figured out his method. You try to copy him, but then you fumble around for five minutes. But not ol' June. Zip, zip, zip and he was done."

"Oh, he could skin a rat in a heartbeat!" says Billy.

Once more, silence overcomes the passengers, as perhaps in their grief they grope for memories.

"He was quick with a word, too," says Orville's son, Junnie, who fished with the man for whom he was named.

"Christ!" says his senior. "I remember one time him and his dad was runnin' out by Catfish Slough. Now they come to that pool, you know the one that catches all the timber; so goddamn many logs and stumps in there. And the old man says, 'Careful, be careful!'

"Junnie says, 'Don't worry, Poppy, I know every bed and crick this part of the river, I even know every snag . . . ,' and right then he run over one that tore a bucket-sized hole in the bottom, '. . . and that's another one right there!' he says."

All laugh heartily.

"Didn't miss a beat, did he?" says Billy.

The auto passes Junnie and Mary's house near the south end, crawls up the overpass, then slides under the palisade and its sheer, eastern slope to which no vegetation clings. "Jesus!" says Orville, "Junnie had more guts than any three of us commercial fishermen put together. 'Christ, let's go!' he'd say. Didn't matter how hot or cold, how rough the water got, he just wanted to fish, by golly!"

"Wasn't he the first to fish off the Proving Grounds?" asks Orville's son.

"I think he was the first to get caught," says Billy.

Eddie, Junnie's cousin, pipes up, "Vinnie always said, 'So what if we get put in jail; they'll have to feed us, won't they?'"

"One night they caught Junnie and Dave and a couple others and fined 'em fifteen hundred dollars apiece," says Orville. "Oh, they meant business! Shots was fired and everything. Next morning we run over, put up the bail, and got 'em all out. Well, soon as it gets dark again, Junnie starts loadin' up the boat. So the old man comes over, 'Yunnie,' he says, he called him that, see, 'cause he couldn't pronounce his name, 'Yunnie, where you goin'?'

"'Back to the Proving Grounds!'

"'Yunnie,' he says, 'you're only gonna get arrested again!'

"'Poppy,' he says, 'that's the only place I can catch enough fish to pay back the fine! They ain't runnin' nowhere's else. Besides, they ain't expectin' us back; they'll all be in playin' cards.' And by golly, he come back with a boat so full of fish she almost sunk at the landing."

After the graveside service, many walk away, tears flooding their eyes. "The south end, hell, the whole town of Bellevue ain't gonna be the same with June gone," says brother Richie as he trudges back to his car. "I know I ain't gonna fish no more, 'less it's pohlinin'. Ain't no goddamn money in it anyway."

In ones and twos the mourners' cars return to Bellevue, below the 2,500-foot palisade, where low-flying clouds might scrape its crags and crown the upper trees' branches. As the last car tops the overpass and slides into town, the site coaxes a final story from Orville Steines.

"One time I found this great big coon lyin' in the woods. Oh, it had to been there a good two, three days. The hair was fallin' out and everything. So I took and dropped it on the overpass, about where we're goin' right now. Well, five minutes later, 'long come Junnie in the pickup. He couldn't miss it, see; he slows down and I hear him say to Mary, 'Get out and put him in the back; but be careful!' Oh, they looked up and down the road, 'cause coon wasn't in season just yet. Why, she even scouted over the bridge where I was hidin' in the weeds. Then she grab it by the tail and swings her in the back of the truck, jumps in, and off they go. Oh, I darn near wet my pants tryin' to stay still down below.

"But Junnie skinned that animal. He dipped the hide in water, made it glisten, and put it in the freezer. Two weeks go by, and then the fur buyer comes to town. You know what Junnie got for it? Forty dollars! 'Course Grant [the fur man] wasn't too happy when the skin thawed out. But what could he do?

"And forty dollars was a lot of money in them days. I guess you could say Junnie got the last laugh on us after all."

Lunch is served in the Lutheran church basement for nearly three hundred of Junnie's friends and relatives. In line for the smorgasbord, people hug and pat each other on the back. Breaths held in a long time are let out; the weeping is over and the silent grieving begins.

Eddie Putman, his wife, Angie, and Hank Pemberton, a local commercial fisherman, trade stories between bits of ham, mashed potatoes, coleslaw, and apple pie. "This happened about ten years before Junnie was born, but it'll give

you a good idea of the way things was back then," begins Eddie. "Across the river from us, just outside Galena, there was three fellows that held up a train. The Silver Marcus Hold-Up, they call it, because they was carryin' government-issue silver that was supposed to pay soldiers and buy some land or maybe both. Anyway, they pulled it off all right, but in the exchange of gunfire, one of 'em got hit. Well, the other two took a look, and right away they saw he wouldn't be able to get away; he was shot up pretty bad. They figure that if he survived, he'd point the finger at them, which wasn't no good either. So right there they opened up the firebox and threw him in.

"Now they never did catch the fellows who did it, but there was two local boys, both from Bellevue, 'Toot' Waite and Bob Casey, who started actin' unusual around that time. Before that, see, they wasn't close at all, didn't have nothin' to do with each other. But now, each one always lived within a mile of the other. They seemed to circle around each other. And every time one come to town, the other strapped on his pistol and followed him. One went to the tavern, why, the other sit at the far end of the bar, in case the first one got into a fight, say, and got hurt real bad or broke the law somehow and wanted to talk. Now, like I say, they never caught them robbers or nothin', but most of the old-timers, seein' how they acted, had their suspicions, figured it was them."

Hank adds, "Years later, Toot built a shack on one of the islands and lived there a good, long while. He had a little farm and everything. I went out there once with Davey [Putman] when we was just kids. While I was scoutin'

around, Toot said to Davey he could pick all the corn he wanted. Little later I run into Davey and he says, 'Hold out your arms,' and when I did he stacks ears across 'em up to my chin. Well, while he's gettin' his, I start for the boat. I step out between the stalks and hear a click. I look up and there's ol' Toot, with as mean a look as you'll ever see on any man's face, holdin' a pistol in my face. 'I didn't give you no corn!' he said. Boy, that stopped my heart for [a] second or two!"

The stories continue: near drownings through the ice or on open water, grudges held or settled, and run-ins with federal officials. "Years ago, boy," says Eddie, who at seventy-seven is quite lean, "a game warden really had it in for me. Wasn't a piece of my gear he hadn't measured, checked, inspected. Well, one winter he come out where I was fishin' on the ice. He looks at my airboat, pokes through the nets and stuff in it, then he checks an old rowboat I had tied to the back. I just use it to skid my gear across the ice. Nothin' but an old tub.

"Now he comes over and says, 'This time I got you!'

"'What for?' I says.

"'You don't have no tag on your second boat.'

"I says, 'That boat's got so many holes it wouldn't float two minutes.' We go at it awhile, but I can see he's gettin' pretty worked up. There wasn't no stoppin' him. So then he give me a ticket.

"Couple days later, when he cooled off some, I went down to his office. I said, 'I want my license back.'

"He says, 'What for?'

"I says, ''Cause you cited me for a nonexistent violation. That boat so-called wasn't no vehicle of conveyance, nor was it intended to be.' Well, we went back and forth, but pretty

soon that temper was gettin' the best of him. 'All right,' he says, 'I'll call my supervisor; we'll talk to him!'

"Well, that was his second and last mistake. He gets Iowa City on the phone and starts to explain the situation. After a while, though, his supervisor interrupts him. 'Who you arguin' with?' he said.

"'But I haven't finished . . . ,' he says.

"'Never mind,' he says, 'just tell me who you're arguin' with out there.'

"'Eddie Putman. Why?'

"'Eddie Putman . . . you're wrong. Hang up the phone and let him go.'

"'But he didn't have any . . .'

"'You're wrong! Hang up the phone and let him go.'

"See, he knew I kept up on them regulations. Oh, I read the book cover to cover and then go over it backwards again. But you know, I never had no problems with the game warden after that. Every time he saw me liftin' traps or raisin' nets, why, he'd trudge off in another direction.

"Yep. 'Who you talkin' to out there?' 'Eddie Putman.' 'Eddie Putman? You're wrong! Hang up the phone and let him go!' Oh, his whole attitude changed after that."

For a moment, talk in the old church basement lulls. All along picnic tables the break is palpable, as if Junnie himself had just strode into the hall, slime of the Mississippi dripping off his waders. Off the river, a fire begun in the furnace, waders peeled off, the cold yet clinging to him, has he just pulled off the tab of an Old Milwaukee? Do Doug Griebel and Jimmy Budde scrape chairs along the floor and sit close to him? All but hanging in the air are a fisherman's words, discoursing upon Mother Nature in crooning tones.

Several look upward apprehensively. Then a wave of conversation breaks and drowns the silence.

That night, Mary and her daughters, Peggy and Tami, their husbands, Mike and Ron, and their children, along with the recently married Doug and Yolanda Griebel, have dinner around Mary's kitchen table. "I remember when Dad started takin' us huntin'," says Peggy. "Over to that crick by Potter's Mill. I got a big red squirrel first shot. Oh, I was so proud! One of the fellows that was along did taxidermy work; he said he'd mount it for me. I remember I laid it out across a stump, near our fire. I kept comin' back to admire him every ten minutes or so . . . his pelt was so smooth and full. Dad said that thick coat meant it was gonna be a hard winter. But I kept imaginin' how that little animal was gonna look stuffed up on my mantle, either runnin' through some leaves or holdin' onto a piece of bark like it was climbin' a tree.

"Oh, I couldn't wait to take him to the shop. Then when I come back to admire him one more time, I found out that they'd cut off the head and butchered it, too. Oh, I was heartbroken."

Tami says, "One time Dad took us out on the islands durin' deer huntin'. Pretty soon a doe come out and pass about ten

feet from where I was sittin'. It startled me at first, but then I worried about everybody blastin' away. It was so beautiful. 'Go on!' I says to myself. 'Go on! Run, run!' But it just took its time, takin' one little step after another. Then six shots ring out, and she fell about fifteen feet from me. Oh, I was sick to my stomach. I couldn't eat any meat for a week, I was so upset. Oh, I hate huntin'. I don't even like bein' around no guns."

"Yep, my sister's different from the rest of us," says Peggy.

After dessert, the family, one by one, departs. After all have gone, there is a knock on the door. An old friend from Maquoketa drops off a freshly baked pie. Mary invites her in for coffee. As they sit, Mary stirs sugar into the black liquid. "Now don't get me wrong," she says, "Junnie was a good husband and a good provider, but many was the time someone'd come into the market when he was dressin' catfish and he'd end up givin' some away. No one come right out and ask, but they'd let it be known somehow. Or he'd always make long distance calls to get information for this or that one and never charge 'em nothin'. Now, nobody worked harder. Everybody knows that. But if he'd been a little better with his business, he would have died a rich man. No one says that; [but] these bills has got me worried . . . oh, I guess I'll manage."

For a few moments, the room falls quiet. The cuckoo clock whistles three times and is still. It is 9:45. Half a block west, the Santa Fe rolls by hauling a hundred cars, its *click-clack-click-clack* quite audible with the occasional groan as tracks complain under a tanker's insufferable weight.

"God, am I gonna miss him and his fishy smell," says Mary.

On the patio, Queenie leaves her seat and scratches, tags jangling. "She accepts it now," says Mary. "She knows Junnie's gone; she's quit her howling."

After a couple of drags on her cigarette, Mary begins again.

"Junnie started fishin' young. Oh, of course his dad took 'im on the river when he was a little squirt, two years old, put 'im in a fish box while Poppy raised his nets. Then when Junnie was in the seventh grade, he started workin' for his dad.

"Now, my husband was a good student. He was real smart, learned quick. But fishin' all night for eight, nine days in a row, which is what they did when there was a run on, didn't mix too well with his studies. Pretty soon Junnie was noddin' off in class and begin to fall behind. The sisters got concerned, all of 'em liked 'im, see. They sent letters, and finally even a couple come over to the house to try and get to the bottom of it. But this was right after Junnie's mother died and things was tight.

"Well, eventually Junnie couldn't keep up no more; he quit school and fished full time. I don't believe he ever finished the seventh grade. He stayed on with his dad, even after he come back from the service, but then when he come to find out Poppy was payin' some of the men more than him, he quit. That's when he went with Eddie and Angie to live on the reservation in North Dakota."

Outside, across the street, a tugboat pushing two barges bellows its presence through the rising fog. As it awaits clearance from the locks ahead, its wake lapping the Iowa shore can be heard. Mary returns to the present. "That last night was the roughest. We started keeping Queenie locked up in the market nights. She'd just howl and howl, wantin' to be with him, but then Junnie couldn't get no sleep. But that Wednesday we let her stay on the porch near him.

"'Bout two o'clock Junnie woke up and called us in out of the kitchen. He was restless, kept throwin' off the sheets, sittin' up, lyin' back down. You know how his heart raced at the end. About 2:30 he had to urinate. I held the cup and he filled it, but when it come out bright red, the color of them roses there, I knew he wouldn't last much longer.

"He unbuttoned his night shirt, and although we hadn't heated the room, the sweat just poured off him. When he tossed some more, we asked did he want some morphine; he shook his head. Then Peg asked if he wanted her to take that plastic breathing tube out of his mouth; oh, he just hated that thing! He nodded and she took it out. After a while, his breaths started gettin' shallower and shallower, one or two a minute. But then about three, he sit up wide-eyed, breathin' hard. Peg and Tami was on either side of him now, holdin' his hands. They was both cryin', tellin' their dad how they was gonna miss him. Said how much they loved him; I told him, too. We was all glad we got to say it.

"Right then a tear rolled down his cheek, first one, then the other. After that he closed his eyes, relaxed, and that was it. Then we took off his shirt, which was soaked in sweat, and held it up so Queenie could smell it. Then we put it on the couch so she could lay atop it, which she done. I think she realized it then, she accepted it, 'cause she's been calm ever since."

Again the tugboat sounds outside, requesting clearance, but once more, unbeckoned, it remains in place. Mightily it strains, engines churning, in order to resist the southerly current. And on a signal it lurches forward, gliding through the Bellevue lock, now free at last to navigate the northern waters.

Mary rises and rinses out her coffee cup in the sink. "I think I'll turn in," she says, "but God knows I ain't gonna get no sleep."

Orville and Mary Steines's trailer home sits on Bellevue's southernmost end. They look out upon a half acre of grass that is confronted by a solid phalanx of six-foot-high corn. Commanding it, a quarter mile distant, is the state park's palisade. As talk begins in the warm, October morning, Orville will squint cautiously, staring hard into a listener's eyes. But shortly, unlike Junnie, his features relent, creasing into frequent smiles. He cannot, in spite of himself, maintain the unforgiving glare of his onetime partner who, during the chummiest of converse, seemed to smolder at some long-ago grudge, some injustice.

"Something you have to understand about Junnie," Orville begins. "Now he was a good worker; he was a helluva worker! Why, when he was sixty-five, near seventy, he carried some of them younger boys. By golly, he did! But," Orville says, narrowing his eyes, "as far as finances goes, he wasn't what you'd call . . . well, he didn't know how to manage his money good; I'll put it like that. He give too much of it away, for one. And then he liked his honky-tonkin'. On the way home, after sellin' his fish, he'd stop in Savanna, Sabula, Green Island; why, over the years he musta left a fortune in small change in those taverns. But that's the way she goes."

The last strand of morning mist floats off the field. Orville looks out again, perhaps peering into the distant past. "Early one spring, me and Junnie and Bill Bowman [Mary Putman's

brother] made a haul out by Kennedy Slough. Hit 'em while they was still bunched together, probably a week before they run out to the channel. So we're comin' home, sittin' pretty low in the water with all them fish in the boat. And when we get near the mouth of the Maquoketa River, we hear a noise. *Chunk . . . chunk.*

"'What's that?' I says.

"'We hit a snag,' says Bill.

"''S too deep,' I says.

"'Somethin's rubbin' against the boat,' says June. 'We pull up the anchor, Orville?'

"'It's right beside me,' I says.

"*Chunk . . . chunk.* We felt it again.

"'Look over on the right side of the boat,' I says to Junnie.

"'Ain't nothin' there,' he says.

"But the scrapin' go on. Nobody said nothin' now; we hold our breath. Christ, it was so goddamn foggy you couldn't see fifty feet ahead.

"'How 'bout the left side?' I says.

"Junnie looks down and says, 'It's ice! Sheets of ice.' See, the Maquoketa River, which had froze solid, was startin' to break up. And there we was ridin' atop some of it, half submerged. Then all of a sudden, from up the mouth of the Maquoketa, we heard a roar. Loud as ten express trains runnin' together. Only there wasn't no tracks nearby.

"Junnie recognized it, though. 'Gun it, Orville!' he says, *'Gun it!'*

"Well, I give it as much gas as I could, by golly. Why, that old tub was so full of fish we could hardly move. No sooner

than we clear the stream when, *whoosh!*, out burst a wall of ice. Holy Jesus! Forty foot high, a hundred foot across! Shoot out with such force it just swallowed everything in its path: logs, buoys, channel markers, run over an island, knock over every tree at the stump, keep goin' and don't stop 'til it hit that bank on the other side, Sand Prairie. See, it'd been all jammed up around the bend, pilin' higher and higher.

"We just sat there, bobbin' in the water. Back upstream you could hear the timber crackin'. Eight-foot oaks, full grown, just snapped in half like matchsticks. Oooh yeah. Three pretty good talkers in the boat right then, but none of 'em was sayin' a word."

Orville relates these stories with a good deal of body language. He twists and turns in his chair, often leaning forward to pin listeners with a penetrating look. Arms fly up or out to make one point or another. "But that ain't nothin' compared to what we done the next spring," he says, savoring the tale's trickery. Now he looks over the corn again, allowing the new memory's details to collect in his head. Then tucking a fresh plug of tobacco behind his cheek, he begins.

"We got a contract to fish one of the lakes out beyond Maquoketa. Why, there were so goddamn many buffalo in there, Christ! every time you dropped a net, it filled up with 'em. Drop 'em, raise 'em, empty 'em, and drop 'em again. Well, before you know it, we had fifty thousand pounds penned up in there.

"We make some calls, and wouldn't you know it? Everybody's cryin' for perch; don't want no buffalo. So first thing I do is get some old carpet and cover all the sides and bottoms of our boats. Now it wouldn't bruise any of the fish when we moved 'em. Then we truck the whole load back to

Bellevue. Dumped 'em all in Roger Keil's pond just off the blacktop. Let 'em lay there and go about our business.

"One morning, 'bout ten days later, the market calls. It's old man Schafer. 'You got any buffalo?'

"Well, Jesus Christ! We had some goddamn buffalo all right, but I wasn't gonna tell him that. 'Oh, I don't know,' I says, 'how much you want?'

"'Can you get me four thousand pounds?'

"'Well,' I says, 'if you stay open late we'll guarantee three thousand. But you better hang up and let us go right now.' See, if I told him how much we got, he'd drop the price, mebbe shut us off altogether. Oh, it seem like those fellows just hated to see us make a living!

"So me an' June took off the waders, poured another cup of coffee, and had ourselves a chat. Then 'bout 'leven o'clock, we drove over to Roger's and start to take out the buffalo. Christ, they was packed in there! But soon as we get a half dozen in the boat, you could tell there's something wrong. Why, I never seen anything like it. All the heads swole up, the eyes bulgin' out. 'The hell!' I says.

"Didn't take long to figure it out, though. Buffalo hadn't eaten in ten days; the heads wasn't blown up, their bodies shrunk.

"'What we gonna do?' I ask him.

"'Cut off the heads and ship 'em,' he says. 'Taste the same, don't they?'

"So that's what we done. First afternoon we brought 'im three thousand pound; next day the same. Meanwhile, we sprinkled soy meal over the pond so they wouldn't starve. Why, you shoulda seen them sons of bitches boil that water!"

Just then a gang of goldfinch leap up from a nearby shrub, aloft once more upon their migratory way to Guatemala, flashing one of nature's most brilliant hues. Orville allows himself a smile. "By week's end, we'd gotten rid of the buffalo," he chuckles, "all fifty thousand pounds of 'em."

On October 7 around 5:00 P.M., a mason pours concrete for the foundation of Junnie's headstone. Before the mixture sets, a large raccoon steps from the woods. En route to the Mississippi River, he walks across the damp cement, leaving his signature.

When Mary speaks to the memorial company that week, they offer to fix things, since the prints will show on either side of the monument base. Mary declines. In fact, she says someone will come out the following week and paint the little impressions gold. "Like leaves in the fall," she says. "It was always Junnie's favorite time of year."

Mike and Peggy Hayes standing at the Mississippi River at the south end of Bellevue one
month before Junnie's passing, Bellevue Dam stretching across the river in the background

Every time I drive north and pass that clear pool above the dam,
I get teary-eyed, 'cause that's where Junnie set his lines and trapped.
Then I look out over the water and think about the fish and
animals there, and I wonder if they remember my dad.

—PEGGY HAYES

I'm numb. It ain't hit me yet. But by next Tuesday, when I walk by his market and there's no light on, that's what I always look for, I'll know then. South end's gonna be awful quiet with him not here no more, you know.

—BIG DAVE PUTMAN

Junnie Putman with Queenie in front of his house a month before he died of cancer

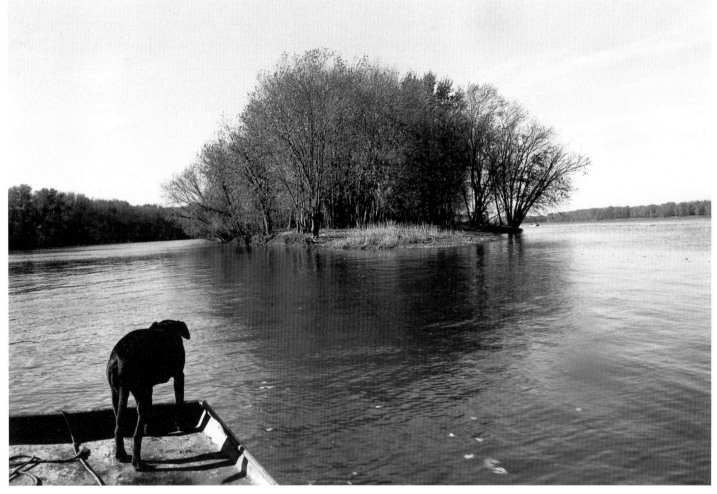

Heading for home in Junnie's boat after a day of hoop netting on the Mississippi
and its backwaters south of Bellevue in early autumn

Been on the river forty-five years. I know every bend, spring, crick, bayou, slough,
and bottom. Hell, I even know where every snag's at . . . least if I couldn't find it today,
I could tell you where it lay yesterday.
—RICHIE PUTMAN

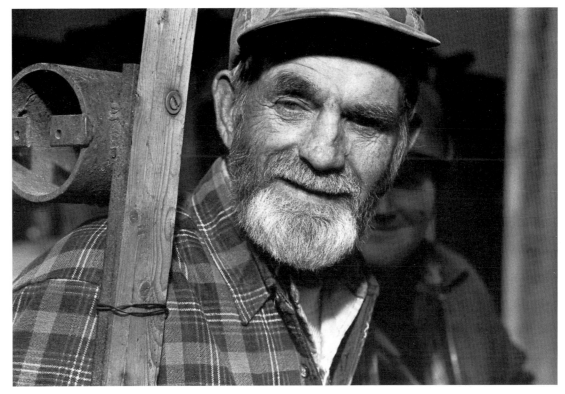

Junnie in a thoughtful pose at his market after a day of trapping and seining

Last fall I was dozin' in the bottom and I hear this noise . . . *drip, drip, drip.*
Opened my eyes and couldn't see nothin'. *Drip, drip* . . . turned my head real slow,
and there was a doe takin' a drink o' water. Coulda reached out and touched her.
I didn't say nothin' or move, just watched for 'bout two minutes. Then I put my
lips together and give her a big kiss. *Smack!*

Oooh, she jerked her head up and looked at me, no more than four feet away,
with them big baby eyes. Twitched her nose. Couldn't figure out what made the
noise. We looked at each other for forty seconds. Then I said, 'Hoo!,' and she took
off down the slough.

—JUNNIE PUTMAN

Richard Younker was born in Chicago and received a B.A. from the University of Chicago. After jobs as a schoolteacher, mailman, and public aid caseworker, as well as a brief acting career, he took up photojournalism, which he has pursued on a free-lance basis for twenty-five years. About forty of his photo essays have appeared in midwestern publications such as *Chicago Magazine,* the *Chicago Reader,* and the *Chicago Tribune Sunday Magazine.* Among his previously published books is *Our Chicago,* which documents in words and photos a variety of Chicagoans, including members of street gangs, pool hustlers, and laborers. He is one of five photographers who illustrated Studs Terkel's book *Chicago,* and several of his pictures from it were screened on the television program *Sunday Morning.* His photo essay "The Wild World of Lake Michigan's Fishermen," published in the *Sun Times Midwest Magazine,* planted the seed for this book, his fourth.

Shawnee Books